WALLINGFORD

THROUGH TIME

David Beasley

AMBERLEY PUBLISHING

Acknowledgements

There are a number of people I must thank for their help in compiling this book. First must be Joyce Huntley, Janet Coles and Connie Green, whose memories of the 1930s and '40s are amazing and without their help this book would have been the poorer. Jenny Jeskins and Richard Lay have both been a considerable help. I acknowledge the help gained from other local history publications, namely *Wallingford* by Stuart and Judy Dewey, and *Crowmarsh* by Bernice and David Pedgley. I would like to thank my wife Ann for her support and encouragement. Finally I must thank Rosie Rogers from Amberley Publishing for her patience – I hope it's been worth it.

This book is dedicated to the following: my three grandchildren Bessie, Ella and Ollie – they have made my life complete. Also to John and Mike, in memory of those wonderful holidays we had in Northern France. Finally to Barbara Passey, my wonderful aunt, who left this world a poorer place.

First published 2013

Amberley Publishing
The Hill, Stroud
Gloucestershire, GL5 4EP

www.amberley-books.com

Copyright © David Beasley, 2013

The right of David Beasley
to be identified as the Author of this work
has been asserted in accordance with the
Copyrights, Designs and Patents Act 1988.

ISBN 978 1 84868 319 8

British Library Cataloguing in Publication Data.
A catalogue record for this book is available from the British Library.

Typeset in 9.5pt on 12pt Celeste.
Typesetting by Amberley Publishing.
Printed in the UK.

Introduction

Wallingford, like so many market towns in the area – Watlington, Wantage and even Henley – has had to change with the times, but unlike so many it has been able to keep its charm as a small town steeped in history. The idea of this book is to show the changes that have occurred, not always for the best. In some photographs we are left with a rather stark view of parts of the town. This book is not just a collection of old photographs, but also a photographic record of the town in 2012. Although it is impossible not to include the most photographed parts of Wallingford, namely the bridge, and the market place. In comparing the old photographs with the new ones, it becomes apparent that, with the exception of parts of the High Street from Goldsmith's Lane to St Martin's Street (areas destroyed in the 1960s), at the roof line there has been little change, thus enabling Wallingford to keep much of its charm.

There was an early Saxon settlement at Wallingford; in fact the town was selected by King Alfred as part of his defences against the Danes and was called a *Burh*. After Hastings, William the Conqueror crossed the Thames at Wallingford, and the Normans later built a castle here in around 1067. During the war between Stephen and Matilda, Wallingford Castle was besieged three times by Stephen.

The Black Death (1348–49) had a severe effect on Wallingford, with the bridge being barricaded to restricted passage, and a number of plague pits have been found in the area.

During the English Civil War, Wallingford (Royalist, of course) suffered badly at the hands of the Parliamentarians. The town was held under siege in 1646 by a Parliamentary force lead by a Colonel Weldon. Wallingford held out for sixteen weeks, and when it finally surrendered it was the last town in Berkshire to fall to Parliament. The town was badly damaged: two arches of the bridge had been removed and a drawbridge installed, St Leonard's was used as a stables and severely damaged by fire, St Peter's was destroyed, and the castle was demolished a few years later.

Like Abingdon and Henley, Wallingford had a number of breweries in the town. In the nineteenth and part of the twentieth century, the Wells family were the principle brewers.

When the railway arrived, it was proposed to build the station just off the market place, but in 1866 a branch line was built on what were then the outskirts of the town.

Ninety-eight Wallingfordians made the supreme sacrifice during the First World War, and in the Second World War some fifty men were lost. After the Second World War, a large council house estate was built along Sinodun, Wilding and Nicholas Roads. The railway station closed in 1959. The building for Paul's Malt was built in 1958; it was so large that it was called 'Wallingford Cathedral'. It was demolished with a spectacular explosion in 2001.

Wallingford has continued to grow over the years. In 1914 the population was around 2,800, whereas today it is about 10,000 and we are threatened with several large housing estates that will increase the population and the congestion even more.

Wallingford was lucky that in the Victorian/Edwardian period there were two prolific photographers, James Alfred Latter and Herbert Rumbold, working in the town, and most of the old photographs published in this book were taken by them. Where possible I have tried to stand where the original photographer stood, at considerable risk to life and limb. As some of the photographs were from buildings that no longer exist I have had to stand as close as possible to the original spot. One aspect missing today that can be seen in the old photographs are the trees: these have been removed as small plots have been developed. With the development of digital photography, pictures can be checked immediately and there is no need to return to take another shot, something Latter and Rumbold would have done. It makes their pictures more of an achievement than those I have taken.

For me, compiling this book has been a labour of love, as are the digital shows that I've performed over the last thirty-five years. I hope you enjoy it as much as I have.

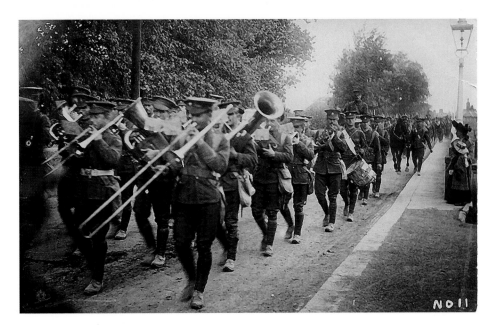

Troops on Their Way to the 100-Acre Campsite in Crowmarsh, *c.* 1905

This camp was one of several located in the Wallingford area, and was used most years leading up to the First World War. Some years nearly 10,000 men were camped in Crowmarsh, made up of regulars and militia. After 1908, when the Territorial Force was formed, they also attended the camps. Below, RAF Benson exercise their freedom of the borough on 5 July 2012. A 140-man parade with fixed bayonets indicated the camp had been granted freedom of the borough. The streets were lined with many hundreds of spectators and the Mayor of Wallingford (Ross Lester) inspected the men. Ater the speeches, two helicopters flew over the town. The freedom was first granted to the RAF on 12 August 1957.

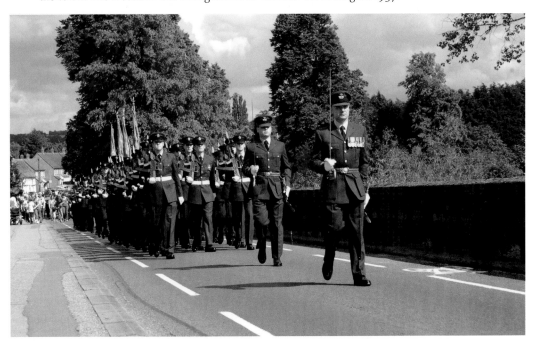

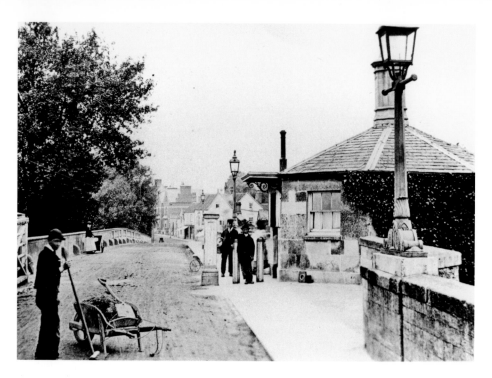

The Toll-House, *c.* 1875

The toll-house was built in 1819 with a bedroom downstairs. The tall chimney behind the house is on Wallingford gasworks. The gates were removed in the 1880 election and thrown into the Jack Ponds. The boy with the wheelbarrow is cleaning horse dung off the roads. The toll-house was demolished in 1934, but it had been used as a private dwelling for a number of years. The stonemason is repairing the stone seats, which had been vandalised for the second time in recent years.

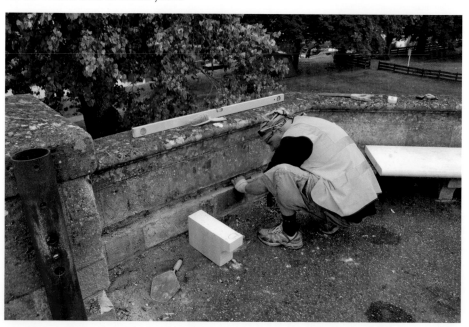

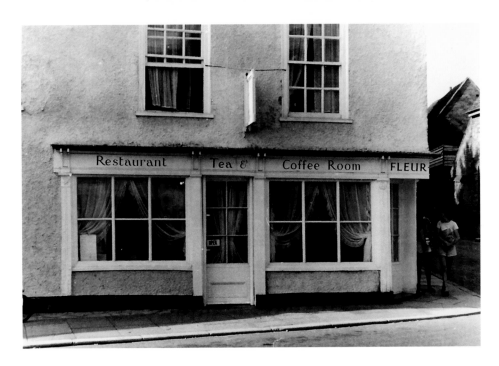

Fleur-de-Lys Restaurant

Seen above is Fleur-de-Lys restaurant, on the corner of High Street and Thames Street, in 1957, when it was managed by Miss Tupling. From 1932 to 1954 Mrs Smardon ran this tea room; in the 1920s Richard Emmett had a hardware shop and fruiterer's here; and from 1890 to 1924 Edward Morris and his daughter Ellen used the premises for their china shop. In the 1950s Margaret and Edward 'Teddy' Perin had the shop, and Mrs Farmer ran the shop in the 1980s. In the '70s and '80s Ron Dunbar managed Stoney's restaurant here, thought by some to be the best eating house in Wallingford.

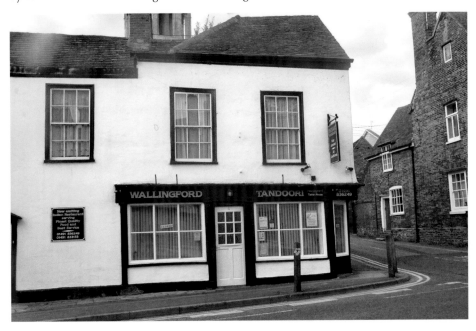

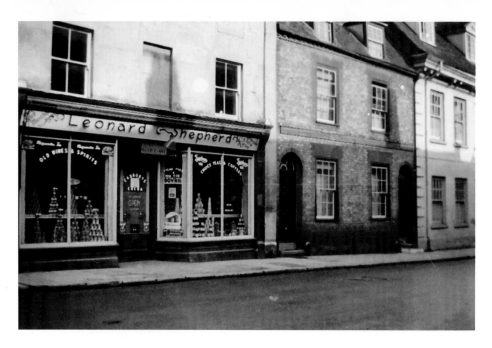

Shepherd's Grocery Shop, 1928

Formerly called Crane & Shepherds until Mr Crane died in 1942. Leonard Shepherd lived at Flint House (now Wallingford Museum) and was twice Mayor of Wallingford, in 1931 and 1932. Mr Billingham of Cholsey was manager here after the Second World War and Alfred Alder also worked here before and after the war. Alfred's mother, Lucy Alder, lived in the house next door. Shepherd's grocery shop closed in 1964. The family moved out of Flint House at same time. The shop was converted into a launderette in 1965.

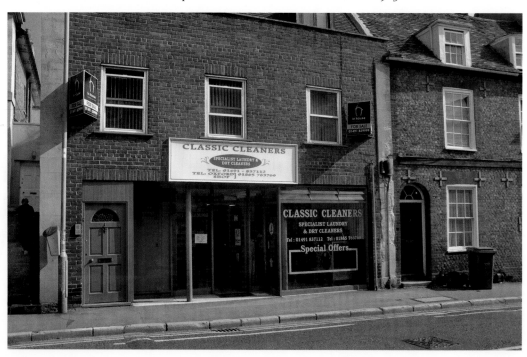

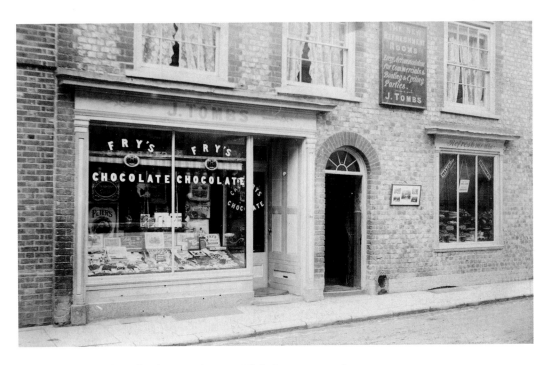

John Tombs' Confectionery Shop, 22 High Street, *c.* 1906
The building was also Tombs' temperance hotel – as a brewery town there was a strong temperance movement in Wallingford. There was often a temperance tent at Wallingford Fair. The house was used as accommodation for the staff of the George Hotel. It was converted into a private house in 2011 and featured in one of Nick Knowles's television shows.

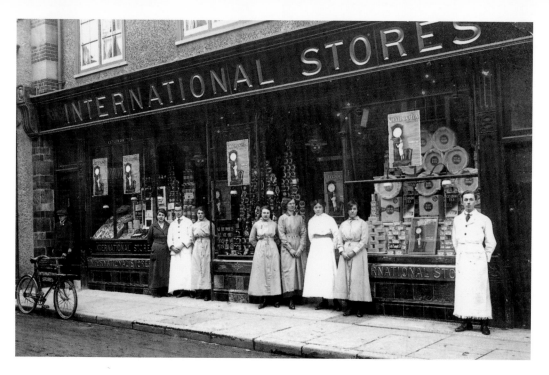

International Stores in the High Street, 1912

In 1895 the shop was known as the International Tea Company. Leonard Fearis was the manager. Managers seemed to come and go quite quickly during this time; four years later Charles Looker was in charge, followed two years later by B. Kerslake. When the International closed, Wallingford lost another grocery shop. In 1912 there were nine grocers and seven butchers in the town, serving a population of some 3,000 (today it is close to 10,000).

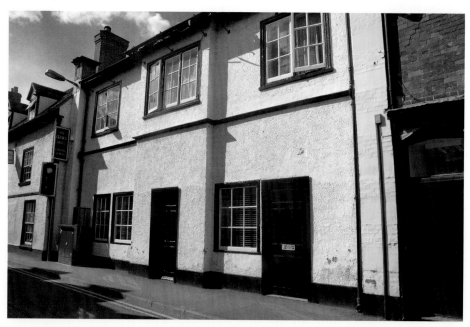

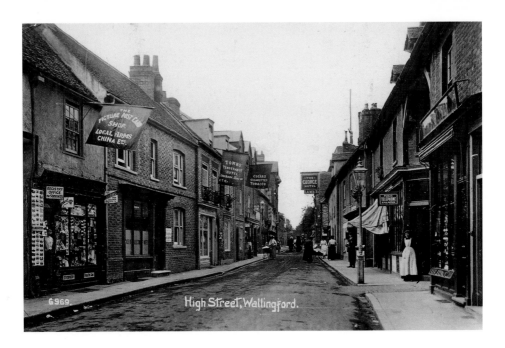

The High Street, 1908

On the left is Relf's toyshop. George Pharaoh Relf managed the shop until his death in 1914, aged thirty-seven. His wife continued with the shop until the 1950s. Tombs' Temperance Hotel was two doors up from Relf's shop. Opposite was the International Stores with Gibbons bakery next door (opened 1870). The building with the green shutters was Beisley's watchmakers, which was managed by Miss Volins from Christmas 1995 until it closed. Where the International Stores was is now the George Hotel's function room and the Avanti restaurant now stands in the place of Hartwell's Café.

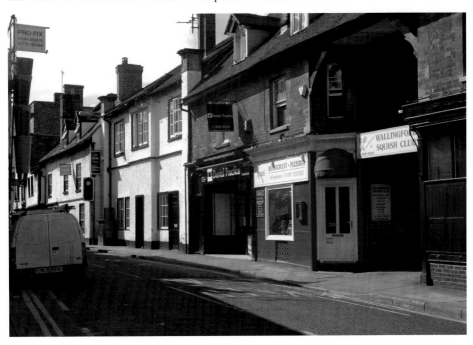

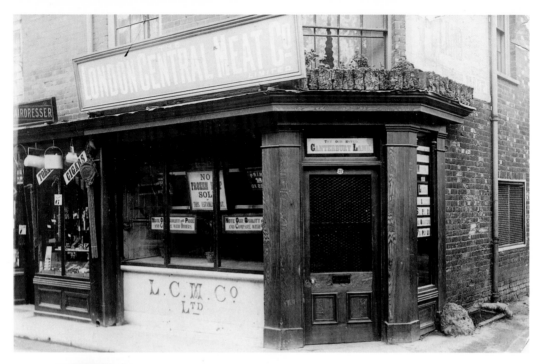

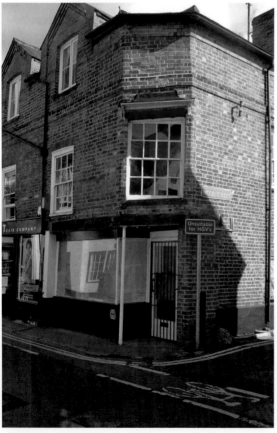

London Central Meat Co., *c.* **1906**
To the left is Walter Emery's
tobacconist's and hairdresser's shop.
Emery owned the shop from 1899 to
1936, when Leonard Shepherd bought
it. When the butcher's closed the
premises was converted to a window
blind shop. The shop next door was a
ladies hairdresser's; it was converted
to a model shop in the 1970s.

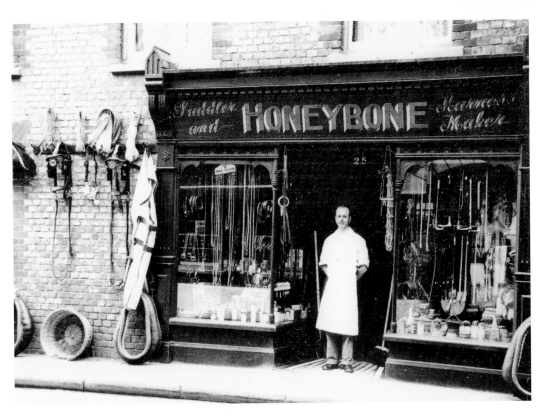

Honeybone the Saddler's, *c.* 1932
Owen Honeybone is standing in the shop doorway. The saddler's closed in the '60s and it was converted in to a hairdresser's in 1999.

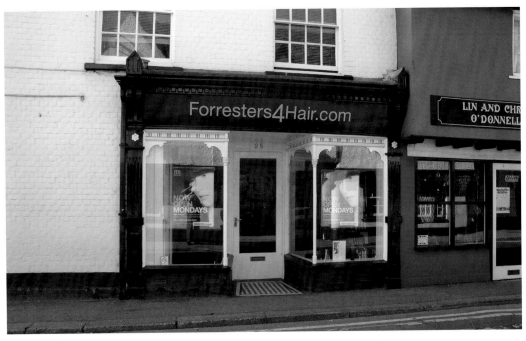

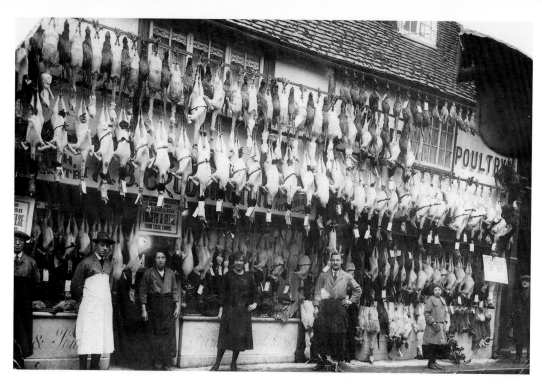

Ben Crudgington's Poultry & Fishmongers, *c.* 1922

Crudgington's came to Wallingford in 1919. Before 1914 Saunders had a butcher's shop here. Lin and Chris O'Donnell moved into Crudgington's old shop in 1992 from St Peter's Street.

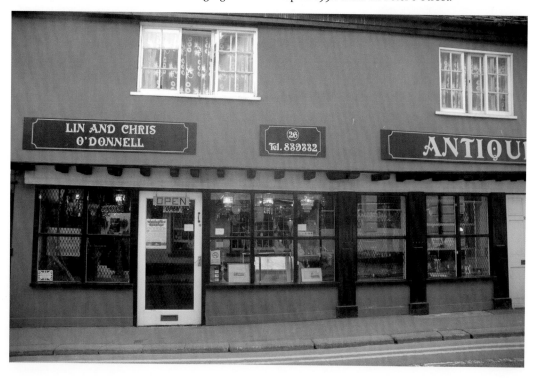

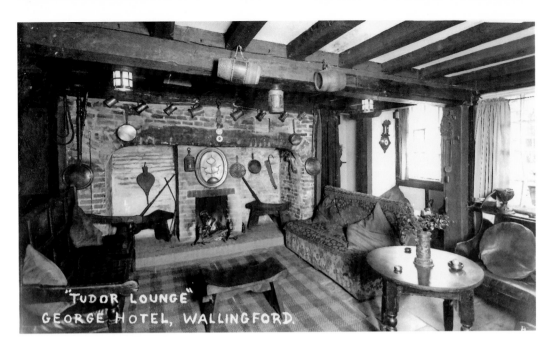

"TUDOR LOUNGE"
GEORGE HOTEL, WALLINGFORD.

The George Hotel, *c.* 1935
In 1920, the manager of this sixteenth-century coaching inn was a Mr Charles Evans, whose son was Lindsey Evans, the well-known press photographer for the *Oxford Mail*. In 1935 a Mr L. Pressland was the owner. The hotel is now owned by the Peel Hotel Group which purchased it from Grace Hotels.

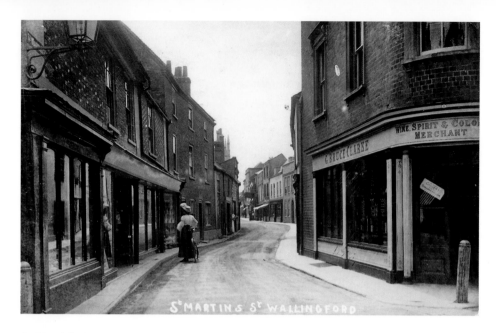

St Martin's Street, *c.* 1910

The shop on the left with the large plate-glass windows is Rusher's china shop. The shop was demolished in 1940 when St Martin's Street was widened. A town councillor at the time stated that it was a waste of public money, as he knew for a fact that Wallingford bypass would be built within twelve months; he was only fifty-three years out. On the right is Waitrose supermarket, designed by Michael Aukett Architects, which was opened in 2005. Previously, Somerfield had occupied the site, but Waitrose purchased the site in 2000.

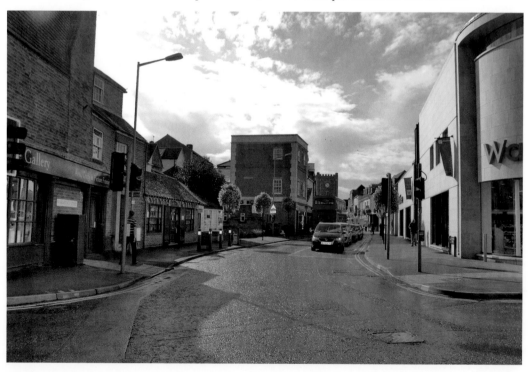

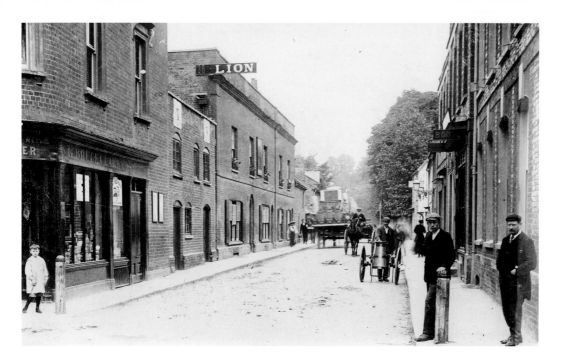

The High Street, *c.* 1906

On the left is Bruce Clark, a grocer who bought it from James Marty in 1901. James Marty jumped from Beachy Head in 1905. John Liddiard was the owner until around 1875. Liddiard was also a candle manufacturer. The casting of the candles gave off a very strong smell around the town. In 1893 James Freeman's tallow-soaked apron caught fire while he was casting candles and he was badly burned. He was able to walk home to St John's Road, but he died of shock a few hours later. Two up from Clark's is the Red Lion Hotel. William Waters was the original landlord, but when the Red Lion closed in 1935 Cecil Low was running it. In the 1950s Martin and Silver had a clothes shop here. Waitrose supermarket was opened in 2005. While the site was being developed, the remains of St Martin's church were excavated. As can be seen, the new structure is in keeping with buildings around it.

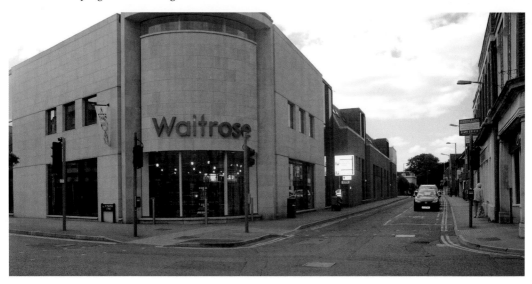

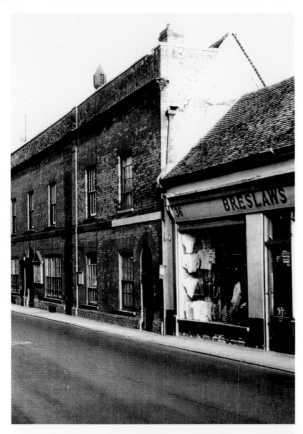

Breslaw's Shop, 1940s

Mr Breslaw came to Wallingford from London during the Second World War. His shop sold ladies clothes and underwear. Next door was the old Red Lion Commercial Hotel, which closed in 1935. It was used as the Municipal Office until 1962. On the right of Breslaw's was Lester Dairy. Now part of the Waitrose building, Key Markets was built on the site. Today, nothing is left to show the Red Lion ever existed.

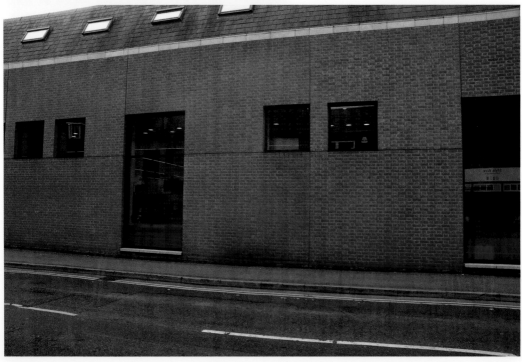

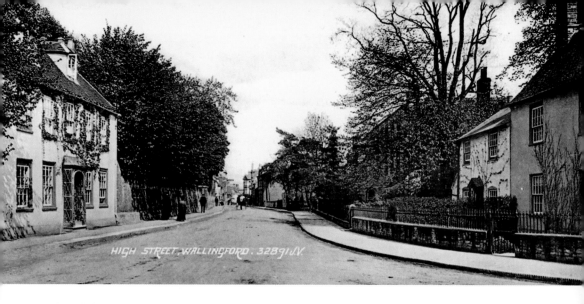

The High Street, Looking East, 1910

On the left is St Mary's priory. In 1903 Mrs Elizabeth Hendley lived here, but for many years it was home to Mr Charles Rogerson, Town Mayor and managing director of Wallingford Brewery Company between 1917 and 1920. The drab Waitrose building has been here since it opened in 2005. St Mary's priory is now a private house, but was once used to register births, marriages and deaths. The whole right-hand side of High Street has been completely rebuilt as far as St Martin's Street.

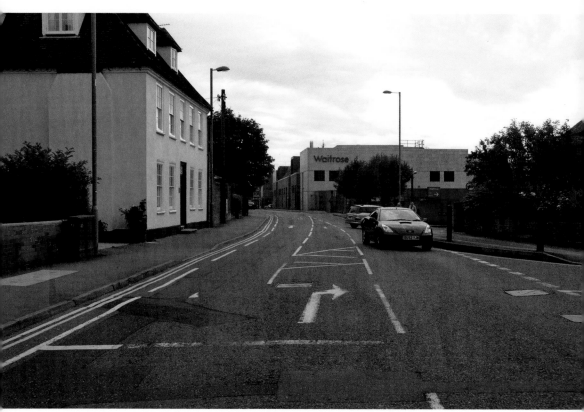

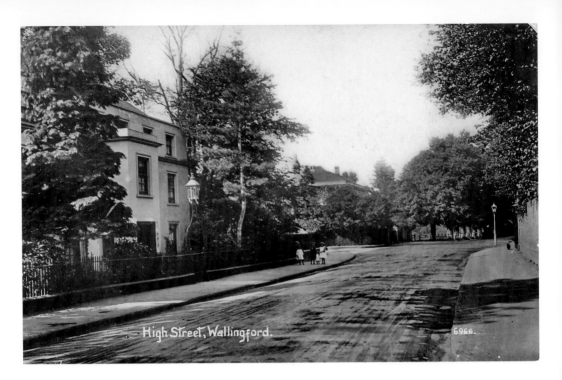

High Street, Wallingford. 6966.

St Alban's Priory, *c.* 1912

The priory is on the left and was once the home of the Dalzell family. The next house is Brewery House, where the Wells and Hedges family both lived. The house was demolished in the 1950s, and in 1962/63 Jenkins was built on the site. In 2002 Jenkins garage was demolished and Waitrose car park was built. The main car park is built on the garden of St Albans.

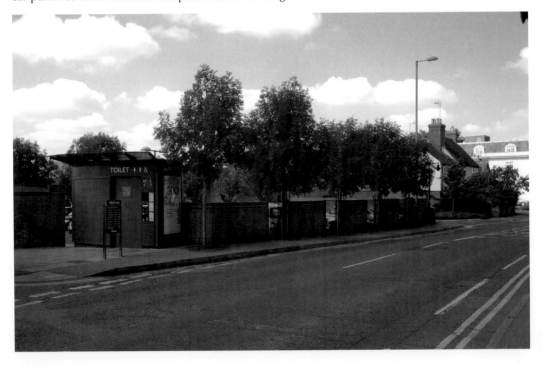

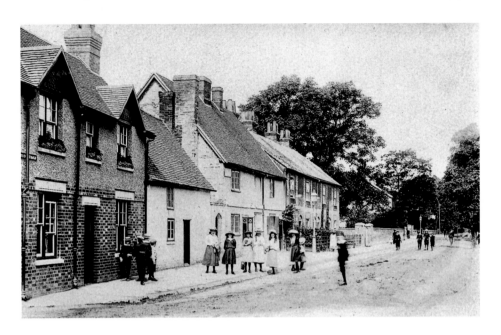

Station Road, c. 1908

The fourth block of houses is Prospect Terrace. Here, seventeen-year-old Ann Good, a servant of Mrs Winmell, was charged with infanticide; the poor girl had worked up to the day she gave birth. Mrs Winmell realised something was wrong so she called a doctor. When the doctor arrived he found Ann in her room with a newborn who was dead – his throat had been cut. Ann was charged. Her trial was the following year; she was found guilty of concealing a birth and was sentenced to eight months imprisonment. The entire row of houses up to Prospect Place was demolished in the late 1990s. The grammar school opposite was converted into apartments in 1998.

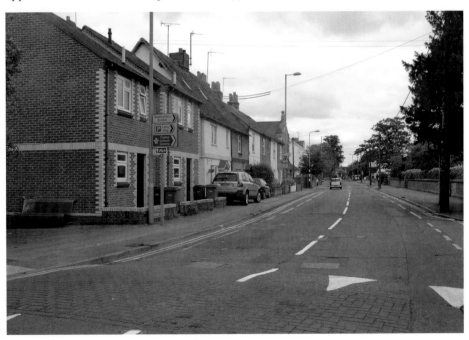

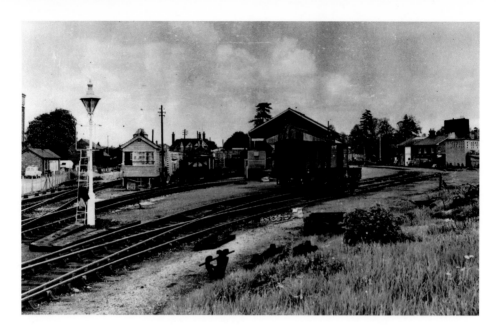

Wallingford Station & Goods Yard, *c.* 1950

Construction of the line began in 1864. It was opened in 1866 with intention of continuing the line to Watlington. The line was sold to the GWR in 1872. The regular passenger services of the Wallingford Bunk, as it was known locally, were discontinued in 1959 and the goods yard was closed in 1965. The old station was demolished in 1969, and the same year the building of this housing estate began. Charter Way is roughly where the station was, with the goods yard being where Hazel Road now is. The line only had a few hundred metres removed, as a malt plant was built adjacent to the railway in 1961 and the line was used to serve the malt plant until 1981, when road transport replaced the rail service. On 31 May 1981 BR ran a last train for enthusiasts called the 'Wallingford Wake'. On the same date the Cholsey & Wallingford Railway Preservation Society was formed.

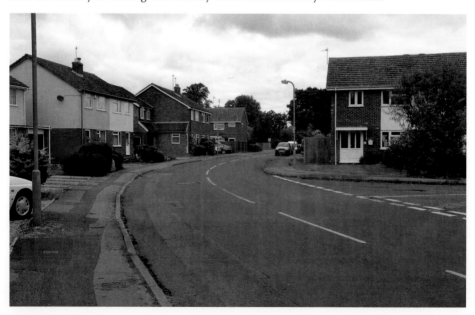

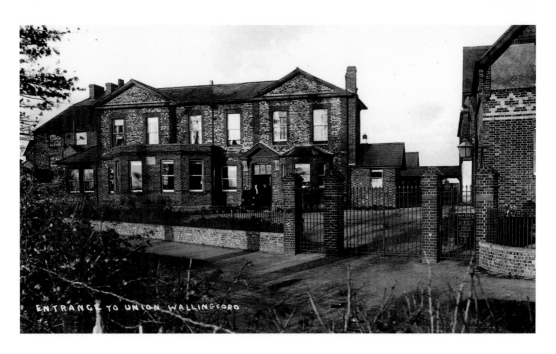

ENTRANCE TO UNION WALLINGFORD

The Wallingford Union Workhouse, *c.* 1910

The receiving rooms were on the right. It was here that poor families were admitted and split up; husbands and wives were kept apart and only on Sundays were they allowed to mix. Today, little remains of the old workhouse, although the above building echoes the old receiving rooms. The developer was encouraged to keep the dining hall but it had deteriorated so much that it had to be demolished.

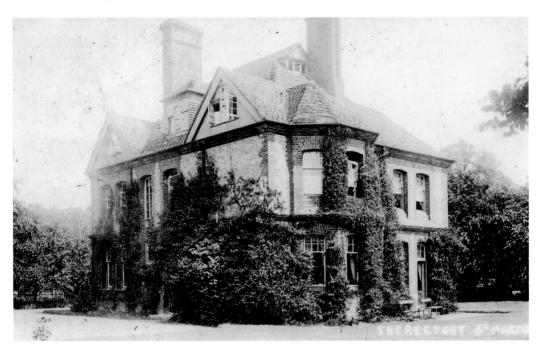

St Mary's Rectory in Station Road, *c.* 1924
The Revd Bowen was the first rector to live here. He was rector of St Mary's for thirty-six years from 1915 to 1951, and in this time he was chaplain to sixteen successive mayors. After the rectory was closed in the 1950s, Ayres used the house as a furniture store and the Esso garage was built in the '60s in what was the front garden of the rectory.

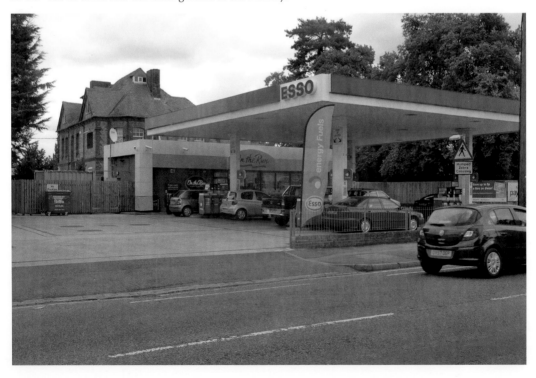

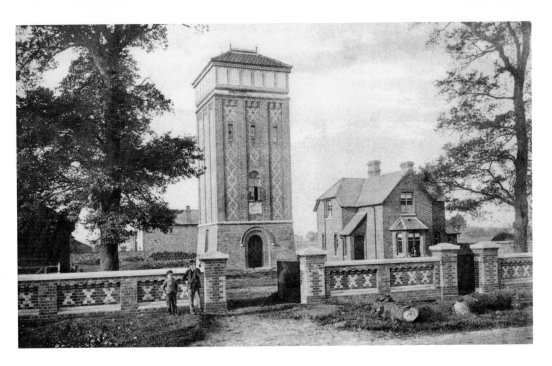

Water Tower

The water tower of Wallingford Corporation Waterworks in Station Road was constructed in 1884 and opened on 1 May 1885. The Mayor, Sidney Payne, and the Corporation paraded from the town hall to the Waterworks. The mayor entertained the Corporation with luncheon at his home, St John's House, after the opening ceremony. In 1912 a new concrete tower was built to replace the old brick one. These flats were built on the site of the old water works in the 1990s, although the original boundary wall was kept, along with the pump house. It can be found at the back of these flats, but is now boarded up and at present not used for anything.

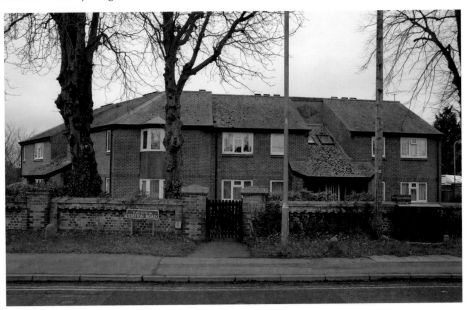

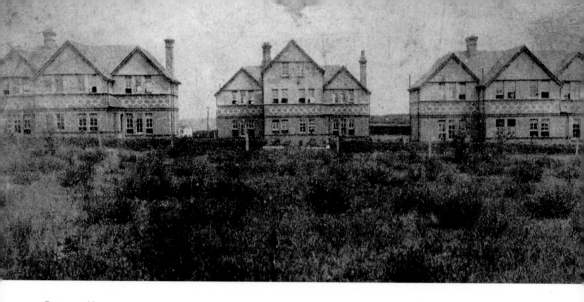

Cottage Homes

The Cottage Homes were converted to apartments in 2005. By the 1960s it was considered better to send the children into foster families rather than large Victorian buildings, and as a result the homes began to close. The three Cottage Homes were opened on 6 April 1900 by Mr T. W. Russell MP, parliamentary secretary to the Local Government Board. Built on workhouse land, they were entirely separate from the workhouse, as it was thought to be better for the children if they were kept away from workhouse environment. The houses that today stand opposite have yet to be built in this photograph. The housed here attended the infants', girls' and boys' school in Wallingford.

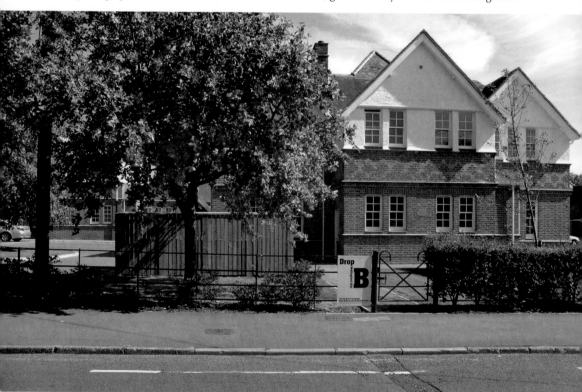

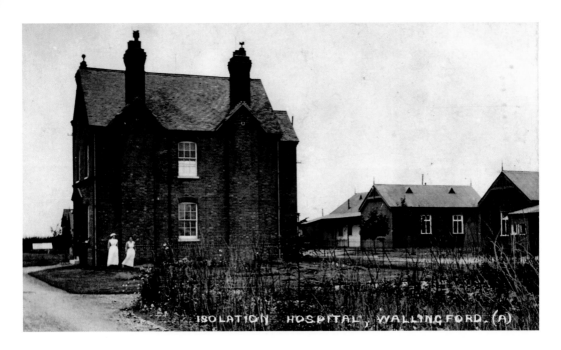

The Isolation Hospital in St George's Road, *c.* 1910

The hospital was opened in 1904. The wooden buildings on the right were replaced with single-storey brick buildings in 1939. Taken over by the NHS in 1948 and renamed St George's Hospital in 1950, it was used as a maternity hospital until 1974. The town used the buildings until 1981, when the site was sold. St George's Hospital was demolished in the 1980s and the site was developed for housing. Rowlands Close was named after a Sister Rowlands who worked at St George's Hospital.

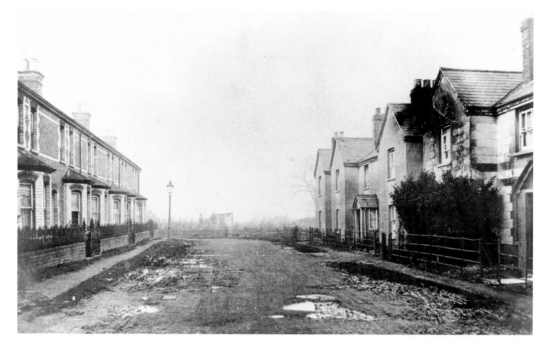

Egerton Road, *c.* 1912

The houses on the right were built in the mid-1880s, but the road did not have a tarmac surface until quite recently so it had many potholes and it flooded in wet weather. The road has since been turned into a *cul-de-sac* and a tarmac surface has been laid. The terraced houses on the left were built by the Wallingford builders Brasher & Sons.

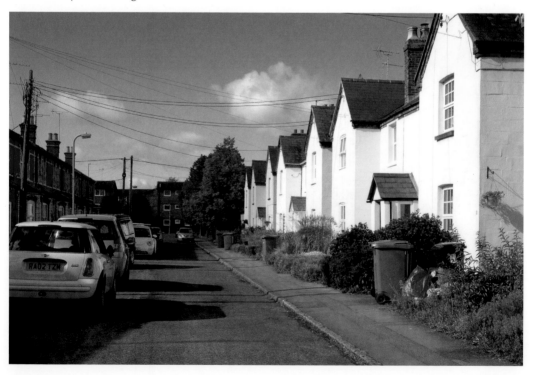

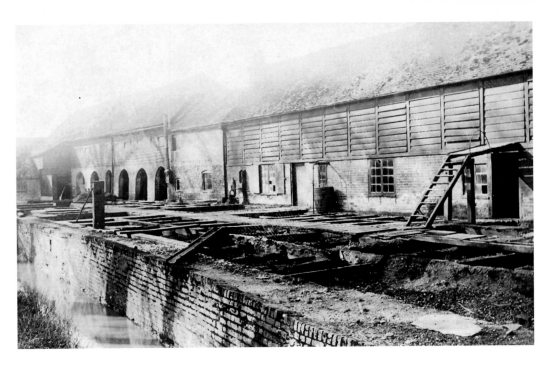

The Old Tannery

The old tannery in Croft Road is pictured, with the town ditch, which used to flow around a part of the Kine Croft. The pits were filled in around 1907, but the buildings weren't demolished until the 1960s. The town ditch was converted to a culvert in the 1960s, and the council later built these houses on the site of the old tannery.

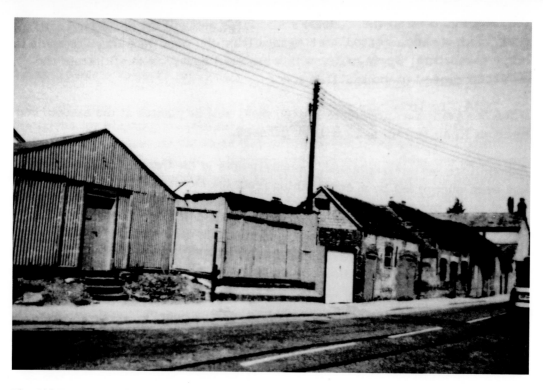

The Old Tannery, Croft Road & St John's Road
There were a number of tanneries in Croft Road and St John's Road. This house on the left was built in 1980s and replaced a watch repair shop.

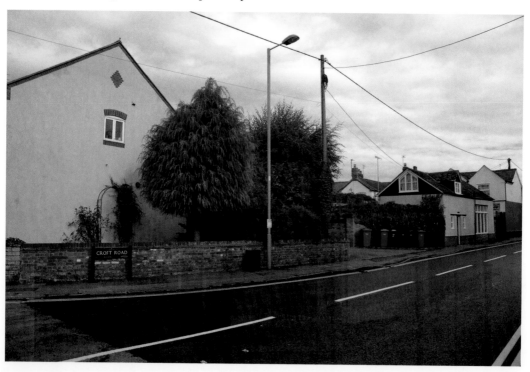

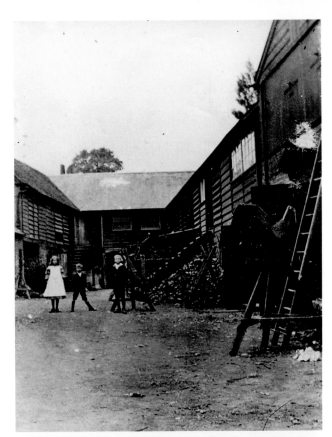

**Charles Crook's Tannery in
St John's Road, *c.* 1912**
Charles Crook lived at No. 14,
St John's Road, which was the
house next door. Charles was a
fellmonger who dealt in hides,
particularly sheepskins. The
tanner's yard was closed in
1924. When Charles Crook died
in the 1960s the building caught
fire. It was later pulled down
and housing was built on the
site, as was this small shop.

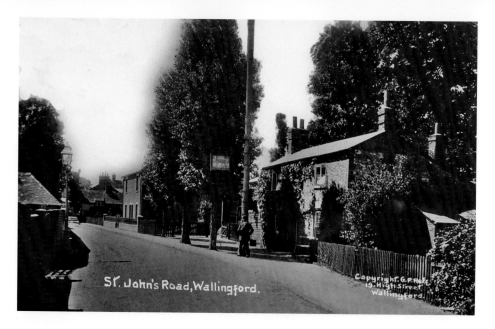

St John's Road, *c.* 1912

The Greyhound public house is on the right. In 1861 (the year he died) William Whichello was the landlord. He was succeeded by his wife Ann and on her death in 1871 John Crook became landlord – it was a position he held for twenty-six years. From 1911 Dan Andrews was in charge, until his death in 1931, when Leonard Jones took over. The large pole in front of the Greyhound is a cast-iron vent, which is part of the Shone & Ault self-cleansing sewerage system. The base of one of these vents can still be seen in Station Road. In 2001 the Greyhound was burnt down and the row of houses named Greyhound Terrace was built in its place. Opposite here the Bosley family had a farm and in the '30s and '40s could often be seen driving their cattle to the Kine Croft to graze.

Wallingford Cottage Hospital, *c.* 1908

The Cottage Hospital was opened in 1880. It was originally called Morrell's Cottage Hospital, but was later shortened to the Cottage Hospital. The hospital was paid for by public subscription and by fundraising. Miss Morrell, who helped to raise the money to build the hospital, unfortunately died just before its completion. The old Cottage Hospital was converted in to a police station in 1930 and was opened in October of that year by the Mayor of Wallingford, Councillor T. E. Wells. It was used as such until March 1960, when it was demolished and new station was built behind. The car park is where the old station once stood.

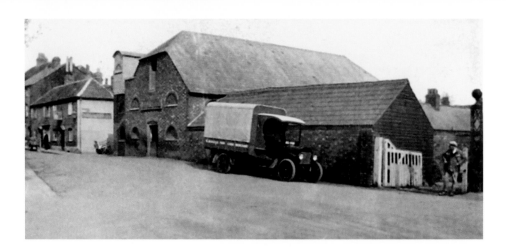

Boughton's Mill, 1920s

Boughton's Mill in the 1920s, when Harry Boughton was the owner. By 1864 the old waterwheel had been replaced with a steam engine. On 22 July, just after midday, the boiler burst. The explosion was so great that the engine shed was completely demolished and debris was thrown more than 140 metres in all directions; some houses close by were severely damaged. A small boy, Alfred Whiteman, was thrown some 40 metres and was found lying in the brook. Though severely injured, he soon recovered. Likewise, the engine driver was blown through the roof of the shed but, unbelievably, escaped with only slight injuries. The owner of the mill at the time was Thomas Adkins. Harry Boughton bought the mill from Mr Worley in late 1881; he applied from exemption from war service in 1916 because he was in a reserved occupation, which was granted, and he died in 1961. John Boughton was the eldest son of Harry and continued the business until it closed in around 1982. The mill has since been converted in houses and flats.

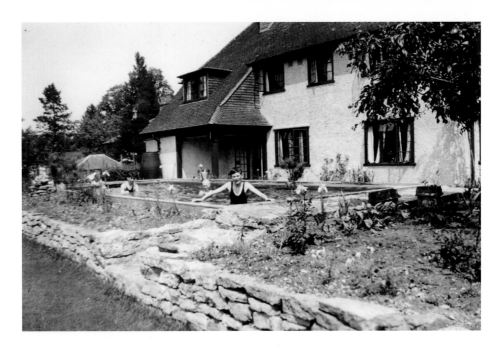

Waterways, Winterbrook, *c*. 1930

John Boughton can be seen in the centre of the picture with his cousin, also named John Boughton, who lived at Ashendon, Buckinghamshire. The female in the white swim hat was Ruth Boughton. This house had a beautiful garden with a small stream meandering through it, possibly diverted from Bradford Brook that runs close by. The house has since been sold to a developer who intends to knock the house down and construct an access road to the fields behind, where a housing estate may be built.

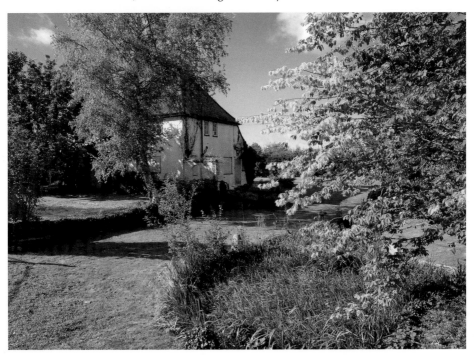

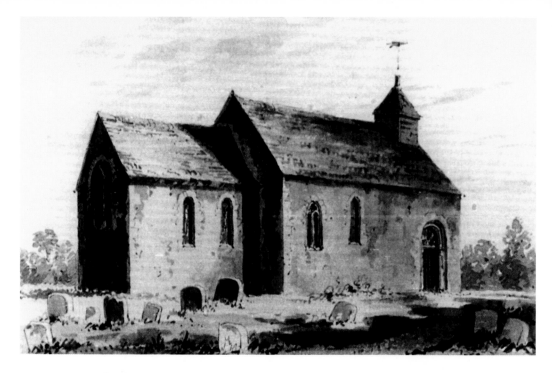

St Leonard's Church Engraving, *c.* 1840

The church tower was built in 1850 when the church was enlarged and restored; the burial ground was also extended. The consecration of the new burial ground was performed by the Bishop of Oxford. The church was lit by oil lamps until 1874 when gaslights were installed. Anglo-Saxon stonework can be seen just above the windows of the north side of St Leonard's church. The church was used as barracks during the English Civil War and badly damaged by fire. It was not reopened until 1704.

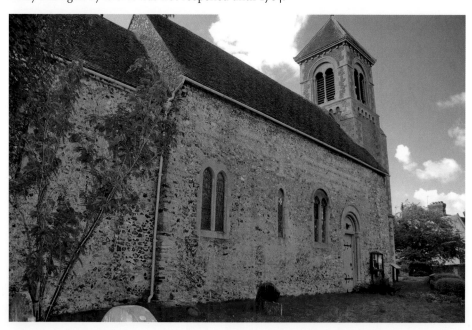

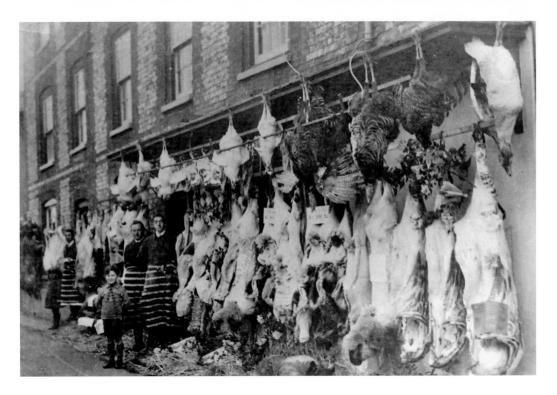

Alfred Lester's Butcher's Shop, St Peter's Street, *c.* 1922

The young boy in the picture is Don Lester, the eldest son of Alfred Lester; Lester also had a slaughterhouse, just around the corner in Wood Street. Lester's shop has now been converted into a private house, but after the shop closed it was first used as an antique shop run by Chris and Lyn O'Donnell. It was then used as Luft's tea and coffee shop. Opposite these buildings was a large house where a Mrs Brooks lived until it was demolished and replaced by a row of shops in 1962.

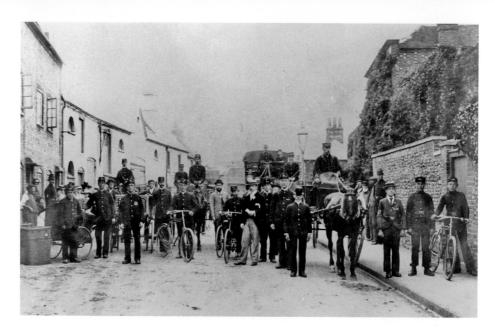

Wallingford Outdoor Post Office Staff, 1899 & 1940

The picture is taken in Wood Street opposite the back entrance to the post office. In 1900 there were four deliveries a day; the first one was at 7 a.m. and the last was at 6.35 p.m. On Sundays there was just one at 7 a.m. You could post a letter in the morning and it would be delivered in Wallingford the same day. The picture below was taken in the yard behind the post office in the market place (now the Old Post Office restaurant). This post office was built in 1936 and is now the Old Post Office restaurant, which was opened in 2001 when the parcel and sorting offices moved to Hithercroft. The beautiful mahogany counter can still be seen in the restaurant, along with the metal step in Church Lane where patrolling policemen used to peer into the post office at night to check if there had been a break-in.

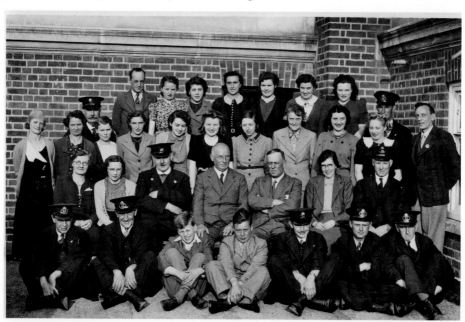

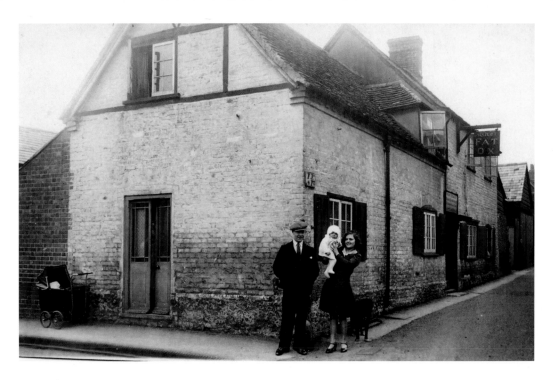

The Fat Ox, 1931

The people in the foreground are Henry Beasley, wife Dora, and daughter Florrie. The Fat Ox had a reputation of being a very rough pub. There was a dosshouse in the backyard where men were able to 'sleep on the line', which meant they slept standing up with their arms draped over a rope that had been stretched across the room. In the morning, the method of waking the men was simply to untie the rope. The Fat Ox was closed in 1940 and used as a private house. The last landlord was Henry Beasley (father of the man above). Reynolds and Johnson used the building as their agricultural store.

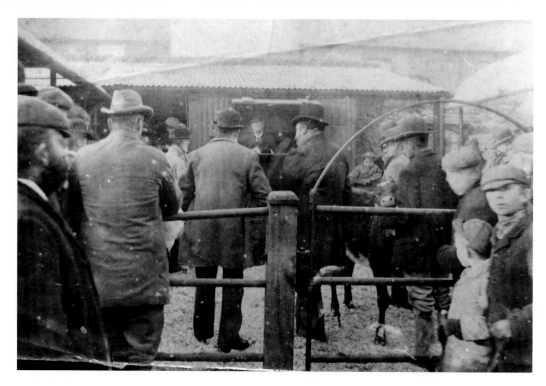

Wallingford Cattle Market, Wood Street, *c.* 1895, and the Cattle Market Car Park, 2012
The market was run by Franklin & Gale auctioneers; from 1899 to 1911 the firm was known as Franklin, Gale & Newton. Cattle were sold here well into the 1950s. In 1900 it would cost £2.20 for a fat pig and a fat heifer would cost £14.75. The cattle market was closed in June 1958, and for a short time auctions of furniture were held there; later, Jim Pink used part of the area for parking his hire cars.

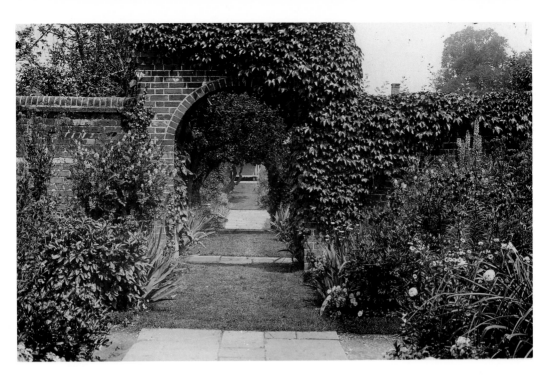

Edward Potter's Garden, Thames Street, 1908

Mr Potter lived at Castle Priory and access to this garden could be gained by using the tunnel that passes under Thames Street from Castle Priory. Mr Potter lived at Castle Priory from 1896 to 1913. The entrance to the garden has since been bricked up. The flats were built on part of the old garden in the 1960s and the Jim Pinks garage occupies what was part of the post office stables.

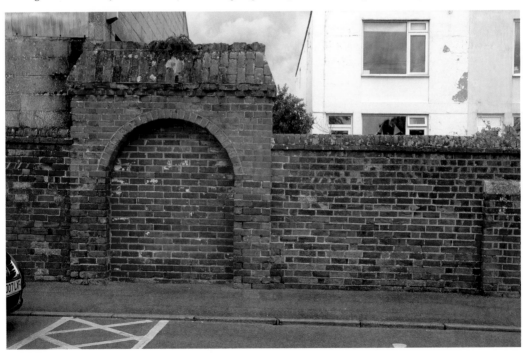

Malthouse

This former malthouse was in New Road, behind the fire station in 1903. Arthur Honeybone was the Captain and he had twelve volunteers under him. In 1914 the council discussed the possibility of building a new fire station in front of the Bull Croft, where the Indian restaurant is today. In 1928 a new station was built in Station Road. The malthouse, pictured left, was demolished in the early 1960s, which allowed the Green Tree public house to build a car park.

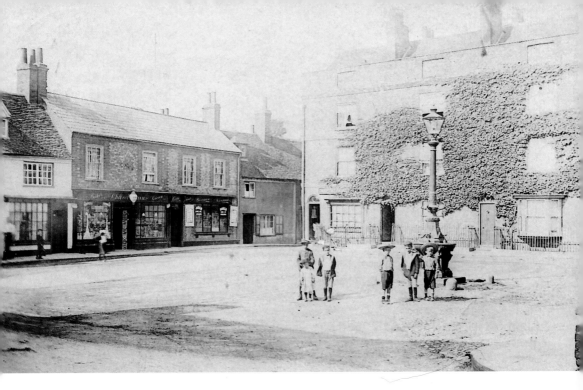

St Leonard's Square, *c.* 1908

The children are standing around Mr Champion's drinking fountain, installed in 1885. Mr Hawkins had a fountain installed in the market place at the same time, but it was badly damaged by a lorry in the late 1930s and removed. On the corner of Goldsmith's Lane was the Rose & Crown pub, which was around in the 1890s. Chamberlain, the grocer's shop, is the large building in the background. The hairdresser's on the left-hand corner became Harold Lovelock's car showroom in the '30s and '40s. Chamberlain's grocer's occupied the red-painted shop. They baked their own bread, which smelled wonderful combined with the smell of ground coffee – something you don't often get today.

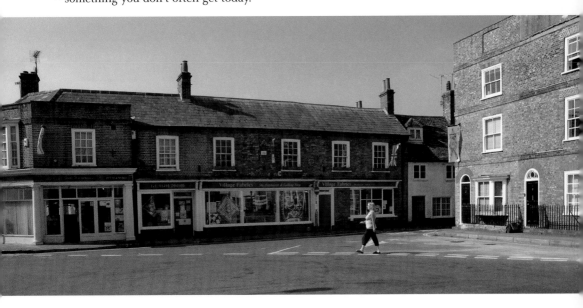

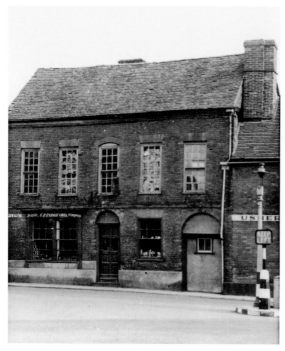

Fred Ponsford, Florist Shop, 1940
A photographic survey of Wallingford buildings was commissioned by the Nation Buildings Record in October 1942. Soon after this picture was taken, a Jewish tailor named Magnus took over the premises. The Green Tree is next door; George Bowyer was the landlord in 1942 and Arthur Giles was the landlord from 1895 to 1920. At one time the Gileses were landlords of the Row Barge, St Leonard's Lane. When New Road was widened in the 1960s, Magnus's tailor shop and the building behind were both demolished. Oak House, which can be seen to left of the red van, was built for John Hilliard in 1847. He lived here until his death in 1878. Mrs Elizabeth Smythe lived in the house from 1901 to 1907 as a boarder; the house was owned by Lucy Mitchell.

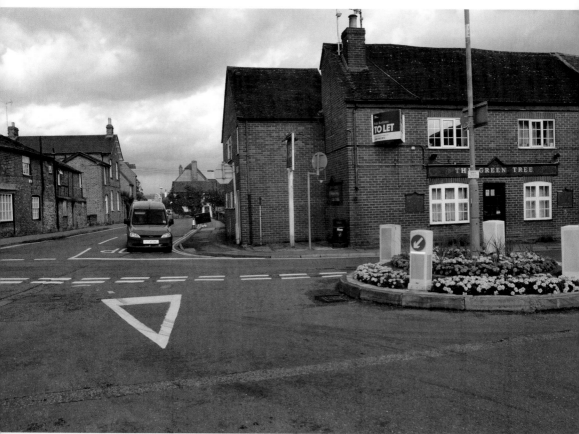

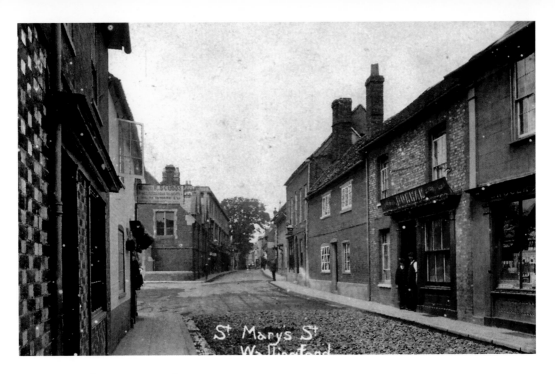

St Mary's Street, *c.* 1906
The building on the left with the pots hanging from the wall is Ernest Scudds', a hardware dealer. Opposite him is Charles Durham, fishmonger. The shop on the extreme right is Ayres, grocer's. Scudds' hardware was demolished when Harold Lovelock built his car showroom. Durham's fishmonger is now a dental surgery.

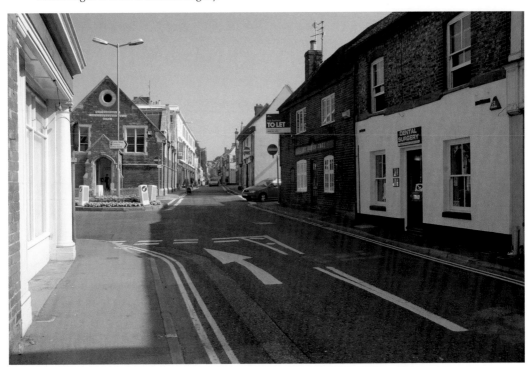

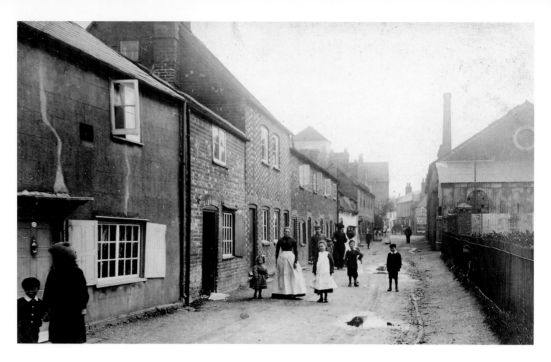

Goldsmith's Lane, *c.* **1904**

All the houses on the left were demolished in the 1960s. At the far end, on the corner of Mill Lane, was the Ironfounders Arms. The landlord was Joseph Young; thirty years before this William Passey was the landlord. Wilder's ironfoundry is on the left. The building was erected in 1869 and converted in apartments in the 1990s.

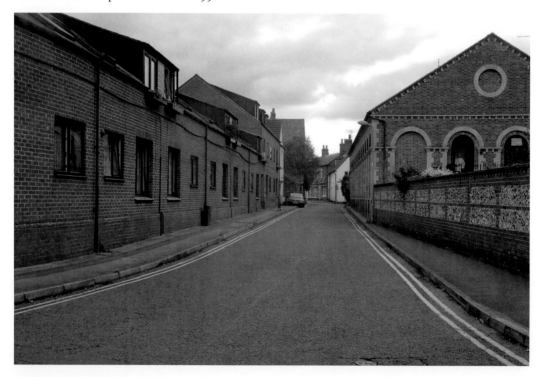

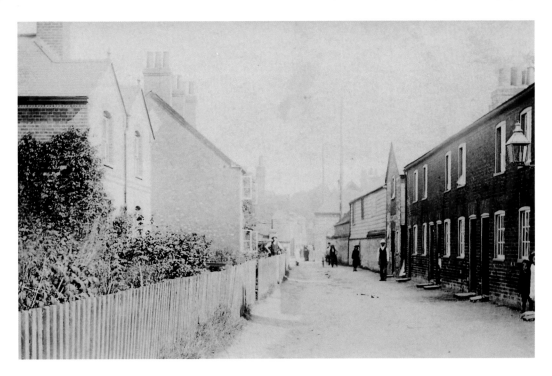

Goldsmith's Lane, *c.* 1908

James Brant lived at No. 23 Goldsmith's Lane, one of the houses on the right. He was one of eight children who lived in a house that had only four rooms. These houses were demolished in 1973 and the entrance to the old Waitrose car park is here now. On the right is the back entrance to St Albans Court. The apartments were opened in 1965 and the court is managed by SOHA, providing both retirement housing and sheltered housing.

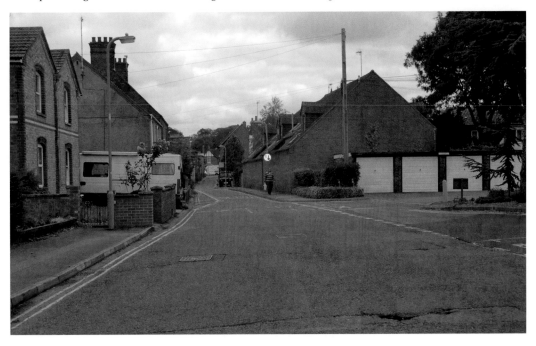

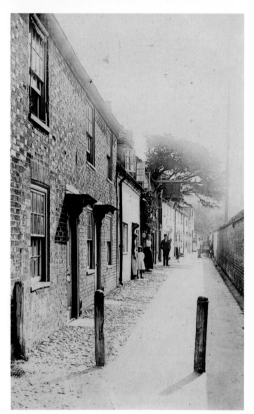

Church Lane (Formerly French Horn Lane or St Mary's Lane), 1910

The signboard of French Horn public house can been seen on the left (No. 10). Emma Giles was the landlady in 1910. She was the widow of James Giles, who was the landlord until his death in 1909. There were three other pubs within a hundred yards of the French Horn. The pub was closed in 1911. The first house in Church Lane, where Jack Page lived, was demolished in the 1970s. After the pub closed it became a sweet shop; Mrs Wells was the first owner in the 1950s and '60s. A former mayor of Wallingford owned the sweet shop later on, together with one on Station Road.

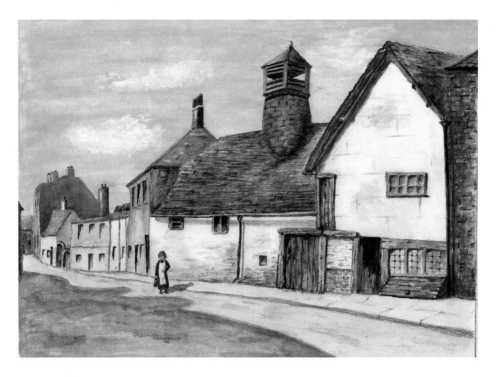

St Martin's Street

This is a copy of Kate Latter's painting of St Martin's Street, originally painted by C. Heidler in 1993. The old Waitrose is now on the site of the malthouse. The old Waitrose building was opened 1973. On this site in the 1960s was Blue Room tea shop owned by Mr Whitely. There were also a number of private houses. The white building in the distance was Wallingford Laundry and next was Robert Marsh, boot repair shop.

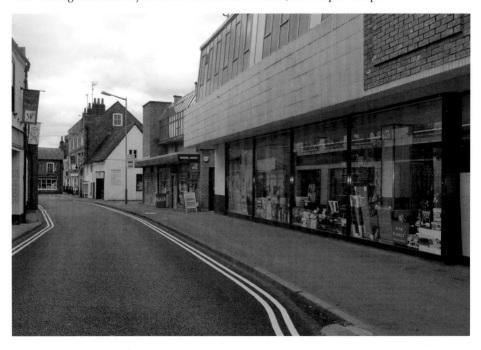

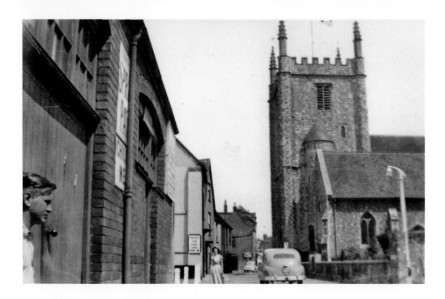

St Martin's Street, *c.* 1958

Honeybone's the stonemason's is on the left. George Honeybone moved to Wallingford in around 1864. William, his son, who took over the business when his father died in 1881, managed the business until his own death in 1939. He designed the Bull Croft gates in 1914, was a captain in Wallingford Fire Brigade, and was a member of the Town Rifle Corps; he had a very fine shot. The white post marks the former position of the cark park for the Regal Cinema, which was opened in 1934. When the Regal was closed on 17 March 1973, exactly thirty-nine years after it opened, the council bought the cinema building and converted it into a community centre. Shops were built at the front of the car park in 1983. The first shop on the left was Lizzie Dunn's. In 1989, the Flower Studio purchased the premises. It then became the Wallingford Book Shop, originally owned by Mary Ingrams (wife of Richard Ingrams, the one-time editor of *Private Eye*). Trish Millar bought the shop from Mary and subsequently sold it in 2008 to Alison Jinks. It is now the Wallingford Flower Shop, owned by Zoe O'Hanlon.

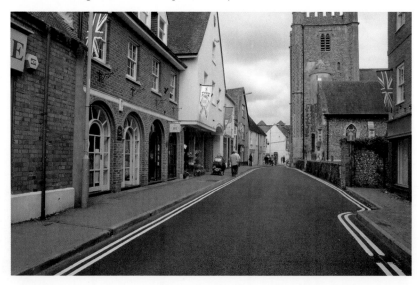

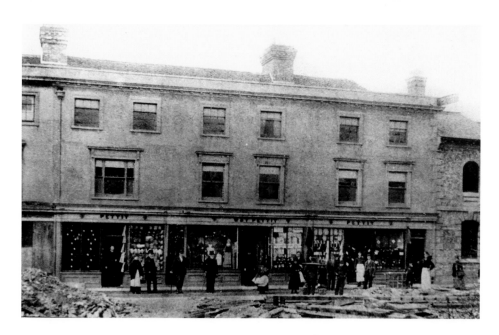

Pettit's Draper's Shop, 1880

The shop was built for Hatton & Rose, drapers, around 1850. William Pettit purchased the shop in 1856 when he moved from Newmarket, where his father had a saddler's shop. The rubble in the foreground is the remains of the Duke's Head public house, which was demolished in 1880. It was nine years before the Primitive Methodist chapel was built on the waste ground. There were many complaints by locals because the shortcut to Wood Street was lost when the chapel was built. The Rowse family (honey makers) purchased Pettit's in 1987, but the name of Pettit's was still retained. Recently, the shopfront was painted similar to the way it was decorated before 1914.

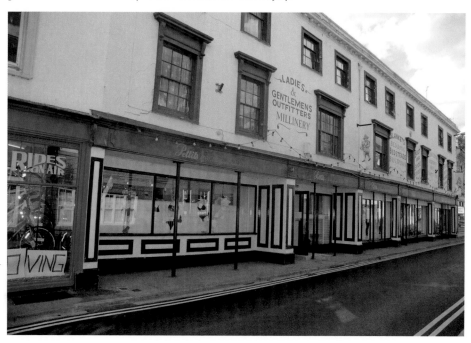

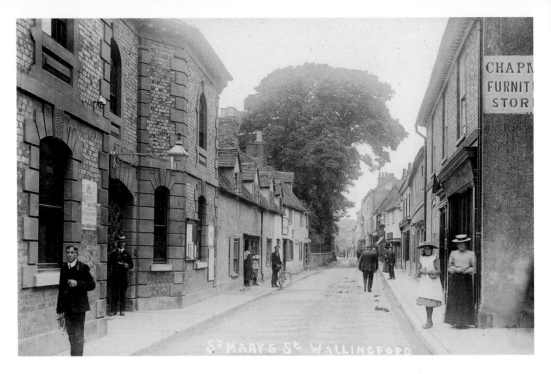

St Mary's Street, *c.* 1908

A postman can be seen delivering mail to the police station on the left. The station was built by Moses Winter and opened in 1857. On the wall in front of the postman is an Army recruitment poster. Next to the cobbler's is the Railway Arms; Calab Bosley and Danny Andrews were landlords. The old police station was converted into St Mary's Arcade in 1956. At the St Martin's Street end was Music Box, a record shop, and at the St Mary's end was a coffee shop. The Pizza Café was opened in 1991.

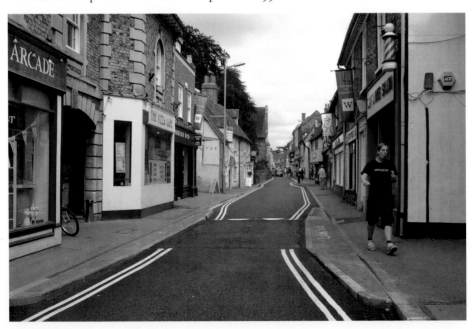

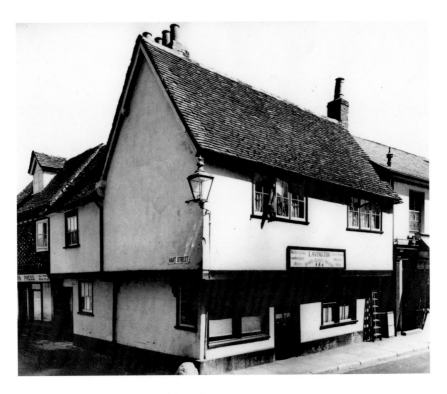

Henry Lavington's Basketmaking Shop, *c.* 1954

To the left can been seen Kilburn Press. From 1784 to 1920 the building was a public house named the Kings Arms. Henry Lavington took over the property in 1928. In the '70s and '80s, Reynolds & Johnson had their wine shop here. The wine shop was converted into a sports shop in the 1980s; it was opened by Geoff Capes, the shot-putter. The Nationwide Building Society was once Chamberlain's butcher's; it had its own slaughterhouse at the back, where the car park is today.

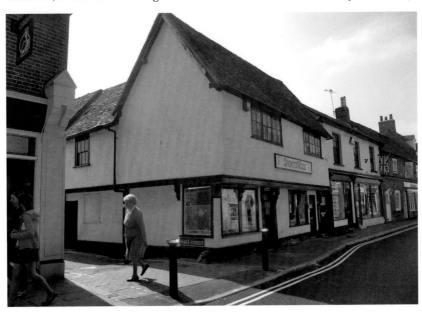

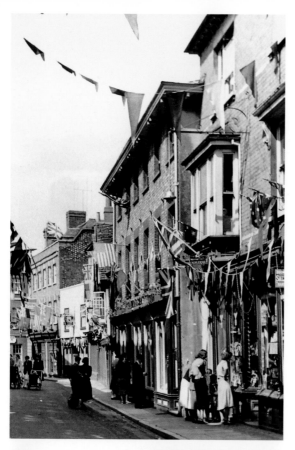

St Mary's Street Decorated for the Coronation, 1953

Arthur Jenkin's newsagent's and stationer's premises are on the right. Arthur took over the business from his Aunt Bessie in 1904, the year he married Edith Cowling. He was proud of the fact that he was part of the Wallingford Rowing Club at the age of twelve years. He often told the story of the *London Times*, which was taken by several residents but by mid-morning was re-collected and by lunchtime was delivered to another house, before being re-collected again and delivered elsewhere for the evening. Arthur died in 1959 aged eighty-one years old. Today Jenkin's shop is a greetings card shop and this end of St Mary's Street has been pedestrianised. The shop on the right used be Stutley Bradford's newsagent's and stationery shop. Before the Second World War his brother Ernest Bradford had a lending library, but after the war it was moved to the first floor of his brother's shop.

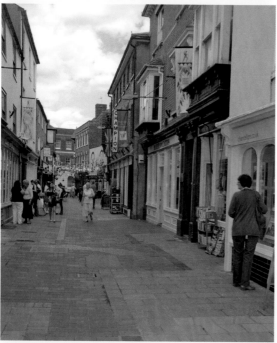

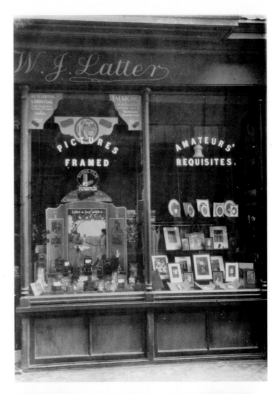

**Latter's Photograph Shop,
10 St Mary's Street,** *c.* **1930**
The Latter family came to Wallingford
from Southampton around 1880 and
three generations of Latters owned the
shop. After Michael Latter sold the shop
it was run as photograph shop, with little
success, until 1994, when Toby English
purchased the shop. A rare and second-
hand bookshop has been in its place since.

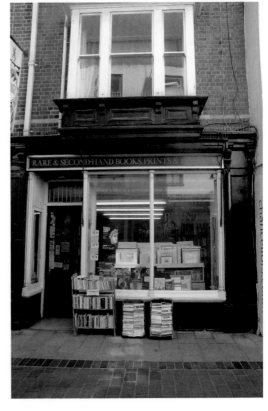

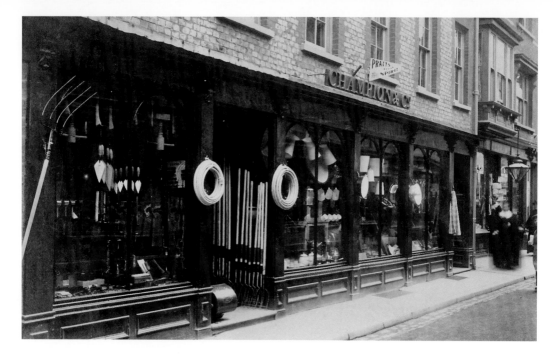

Champion's Ironmonger's, c. 1908

John and Thomas Champion opened their shop in 1842. In 1892, Champion's took one of their apprentices, a William Crook, to court because he ran away and joined the Army. He was sentenced to return and finish his apprenticeship. The shop beyond Champion's is Arthur Jenkin's shop. This was once Wallingford post office; the words 'post office' were spelled out in red and blue bricks in the pavement. As can be seen in this 2012 picture, Champion's has changed very little externally. Allen & Harris estate agent's on the left used to be the White Hart pub; it was closed in 1962.

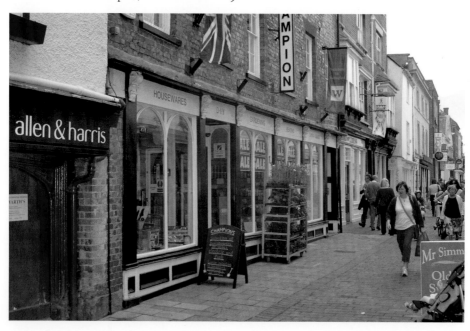

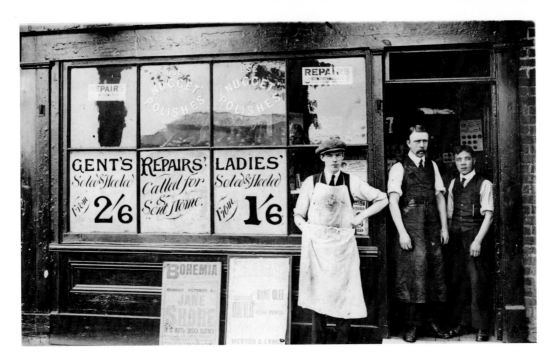

Dawson's Boot Repair Shop, 59 St Mary's Street, *c.* 1920
From left to right: Joseph Lay, Albert Dawson (the owner), (?) Lott. Next door on the right was John 'Tacky' Marsh, also a boot repairer, called tacky because of his habit of keeping boot tacks in his mouth. Mr Dawson took over the shop from Mr Spackman in 1902. A dress shop was here in the late 1980s before a travel agent's moved in (the present travel agent moved here in February 2006), and to the left was 'Dougie' Selwood, hairdresser. In the 1940s, George Hurst, also a hairdresser, owned the shop.

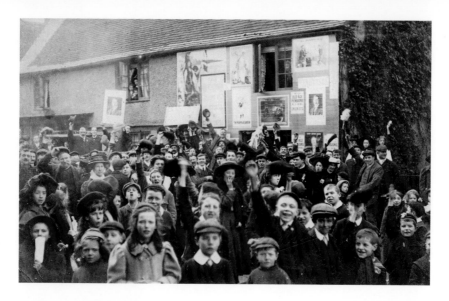

Election Day, December 1910

The buildings behind are adorned with Conservative election posters; the building was used by the Conservatives as their election headquarters in Wallingford. This was the second general election in 1910; the first was held in January. Major Henderson, the Tory candidate, retained his seat with an increased majority; it is interesting to note this was the last British election held over several days. The building on the left was Joseph Harding's premises, and from 1920 to 1935 the shop was used by Harold Wilkins as a flower and fruit shop. In 1936, the buildings were demolished and a post office was built, which was closed 2000. This post office was opened in December 1936 by Major Sir Ralph Glyn MP, High Steward of Wallingford. The top floor was also a telephone exchange – 250 lines had been installed in Wallingford by 1936. In his speech, Sir Ralph quoted the story of the Wallingford postman who took the mail to Thame and Aylesbury by horse van in the 1900s. On one occasion he ran into deep snowdrifts but, undaunted, he unharnessed the horses, strapped the mail to them and rode over 20 miles to Aylesbury. Were they made of sterner stuff in those days?

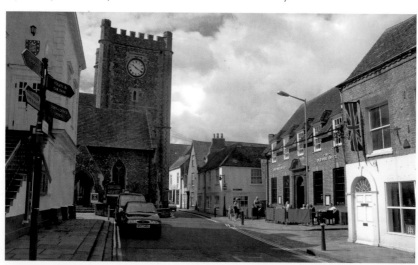

The Corn Exchange, *c.* 1900

The Corn Exchange was built in 1856. Before it was built, farmers would meet under the town hall to buy and sell their corn. It was also used as theatre, and at one time was the headquarters for the local Territorial Force. Before 1914 the Corn Exchange was used on some days as a cinema. It closed in 1934 when the Regal Cinema was opened. During the Second World War the building was taken over by the Ministry of Food. With the Regal closing in 1973, the Corn Exchange was later reopened as a cinema.

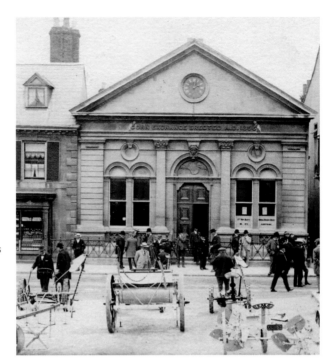

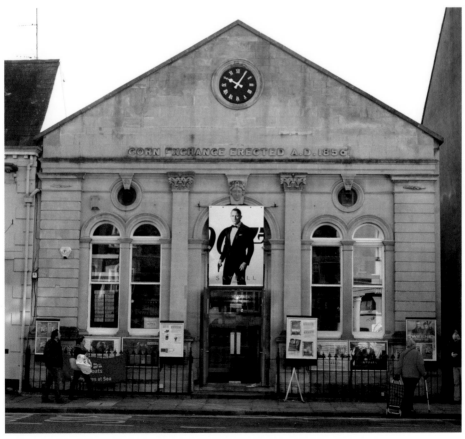

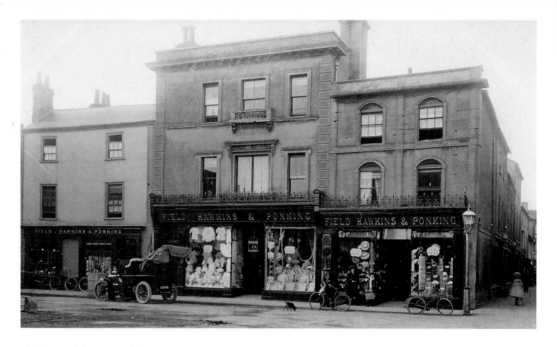

Field, Hawkins & Ponking, *c.* 1910

Thomas Field started this drapery shop around 1850; he also owned a brewery in Shillingford. Henry Hawkins originally worked for him, but by about 1860 he had become a partner. The shop was refitted around 1908. The building on the left was an old post office, when George Christie was postmaster. The left-hand side of the shop was demolished in 1979. The Hawkins drinking fountain has since returned from the Bull Croft, where it had been moved in 1921 when the war memorial was installed.

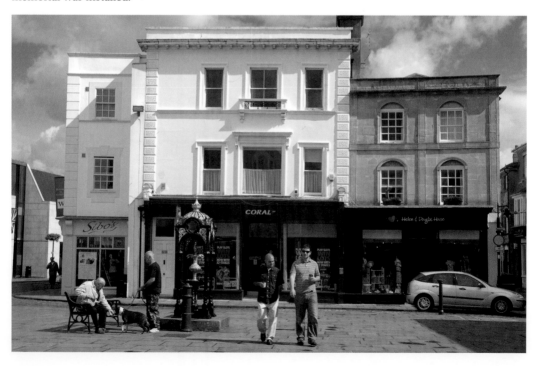

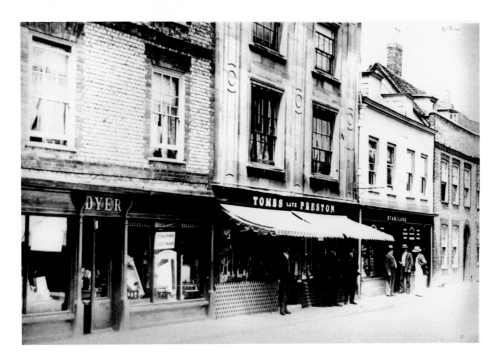

Tombs' Ironmonger's in the Market Place, 1909

Henry Dyer on the left was a cabinetmaker and upholsterer, and John Tombs ran the ironmongers. He moved from No. 22, High Street. The third shop was owned by Charles Staniland, grocer, who managed the shop after his father George retired. George was a well-known pianist and he rebuilt St Agatha's, Brightwell. When John Tombs died in April 1920, Frank Whiteman, who had been Tombs' manager, took over the shop. When Whiteman's shop closed, the chemist's Savory & Moores took over the premises.

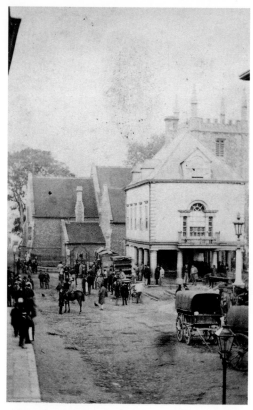

Market Place, Looking South in the 1880s
The Corn Exchange is open as there are a number of farm wagons and equipment in the market place. St Mary's church looks different, as the Wells chapel was not built until 1911. The little black marks near the men are not blemishes but chickens roaming free. The Wells chapel can be seen in the modern picture. The market place was pedestrianised in 1979. The plaque on the balcony of town hall commemorates the Queen's visit in November 1956. On the right of the balcony is a plaque that commemorates the RAF being the given freedom of the town in 1957.

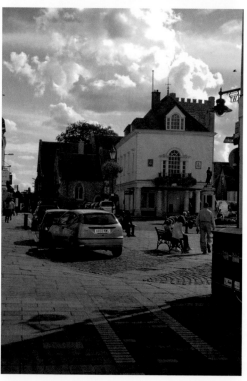

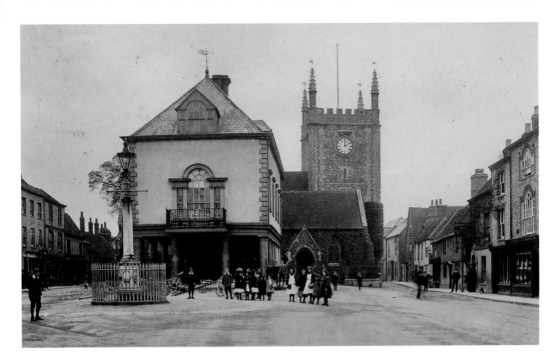

Market Place, 1910

Whenever a photographer was taking pictures there often were children watching him, which adds interest to the photograph. On the left, the first shop is Lloyd's bakery, and next-door is the Oxford House pub, the landlord being Thomas Tappin. The next two buildings were removed in 1936 when the new post office was built. On the other side of Church Lane was the Eight Bells public house. On the right is Hedges solicitor's, where the Golden Bough, a fancy goods shop, once occupied the site. The shop was owned by a Mr Serruya, who was originally from Malta.

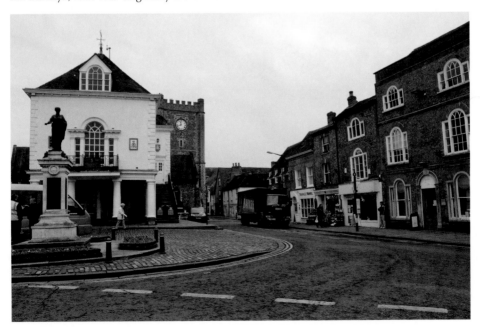

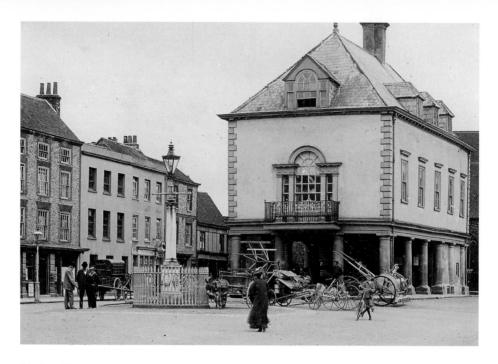

Market Place, *c.* 1907

Richard Wilder, who owned the iron foundry, also made farm machinery, and on the days the Corn Exchange was used he would display his range of machinery for the farmers to see. To the left of the Walcroft Column is Wallingford post office, opened in 1893. The major change to the outside of the town hall is the realignment of the steps. Originally the only entrance to the hall was underneath, but in 1933 steps were built outside; they turn to the left and so that any person coming down would step into the road. Boots the chemist is now on the site of Jenkins garage and also where the old post office was.

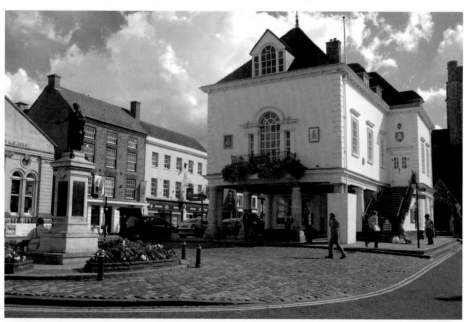

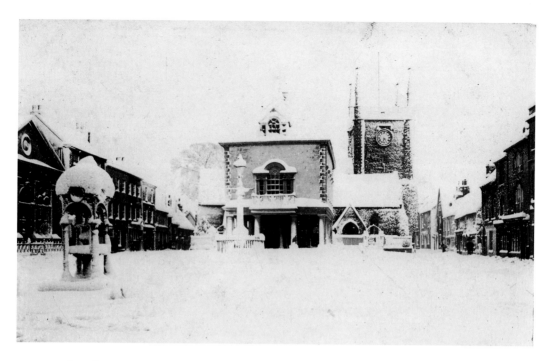

Market Place, 1908

Wallingford market place is seen here on Sunday 27 April 1908, the day after the snowstorm. In twenty-four hours, 500 mm (20 inches) of snow fell in southern England. It is interesting to note that the late mail delivery on Saturday was not abandoned, although the postman whose round was on the Berkshire Downs near Blewbury took refuge in a barn. Below, Wallingford market place in February 2010. The winter of 2009/10 was the coldest winter for thirty-one years, only outdone by the December of 1890.

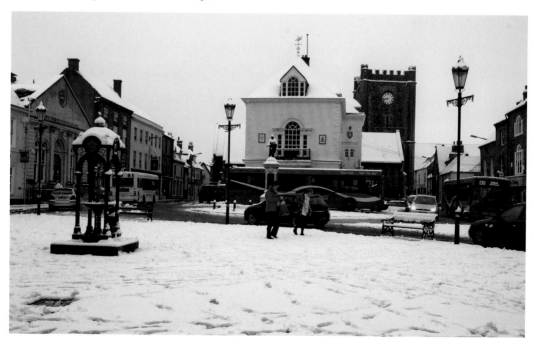

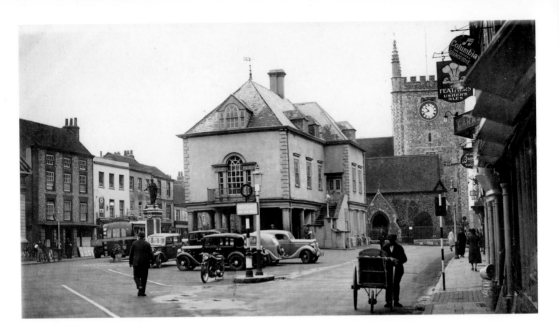

Market Place, *c.* 1936

The building on the right was Frank Whiteman's ironmonger's shop; note the Corporation road sweeper with his cart outside Whiteman's. Over to the left is an Oxford City Company bus, which went on to Reading. The bus is standing in front of Frank Jenkins garage, which was opened in 1912. The building with the billboards is Franklin & Gales Auctioneer's offices. The market place was pedestrianised in 1979. Franklin & Gales was converted to a baker's in 1980. K. P. newsagent's, on the right, was originally the Feathers Hotel before the newsagents took over the building. It was occupied by Walkers Stores, a self-service grocer's.

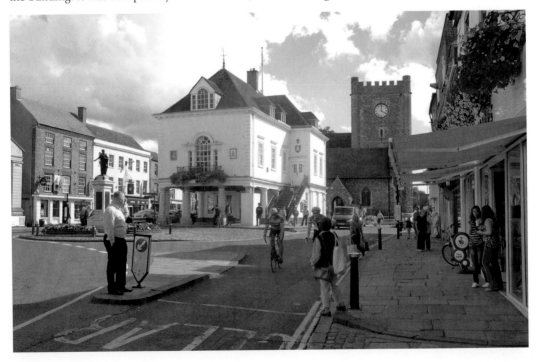

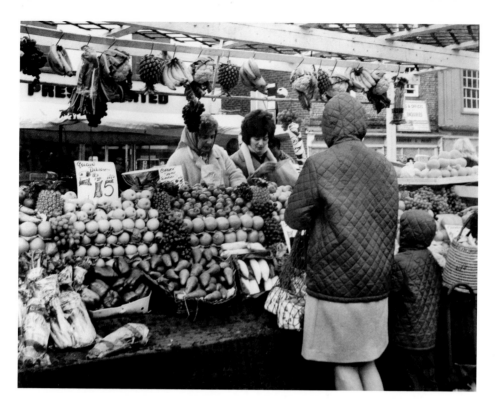

Friday Market, 1964

This photograph was taken by Bill Tappin. Wallingford market is held in the market place, as it has been for many years. In 2006 a farmer's market started up in Wallingford, but it is only since 2010 that it has been on the present site. The only thing to have changed are the prices. The market today is confined to a smaller area.

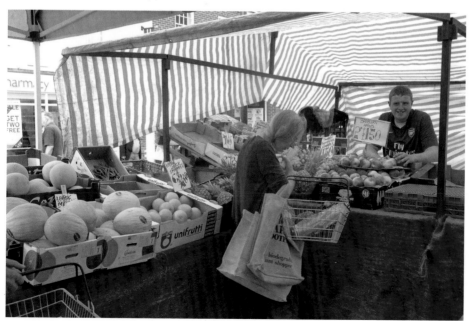

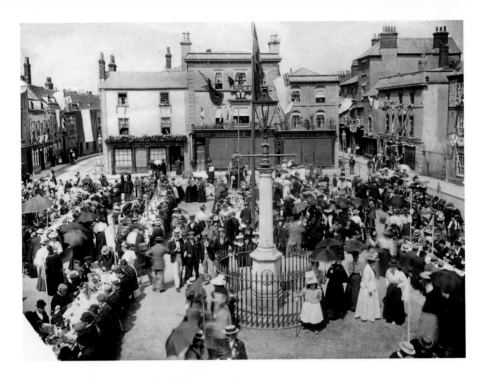

Queen Victoria's Diamond Jubilee, June 1897
This photograph was taken at about 1 p.m. when the men are having their lunch served by the ladies of the town. The ladies were later given a tea with the children, an improvement on ten years, before when the ladies were given 1s but no lunch or tea. At the Queen's Coronation celebrations the women weren't invited at all. The tea party in 1955 was to celebrate the 800th anniversary of Wallingford becoming a borough. As part of the celebrations a pageant was held in the castle grounds, as well as a river pageant, bonfire and fireworks in the Kine Croft.

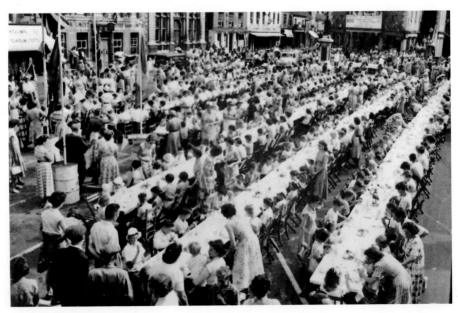

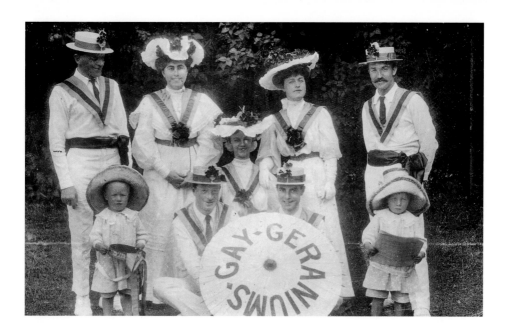

The Gay Geraniums

The Gay Geraniums concert party performed at local fêtes and regattas before the First World War. The man in the back row on the left is Percy Turner, a boatbuilder from Lower Wharf. The two children are his twin sons, Eric and John. A picture of the two boys was used in a soap advert in 1905. Wallingford's answer to the Beatles, the Gangbusters, who were very popular during the 1960s and '70s, played alongside such acts as Gerry and the Pacemakers and Kenny Ball. Incredibly, now in their seventies, they are still performing. They are, from left to right: Johnny Hobbs (singer), Johnny Evans (lead guitar), John Jeskins (bass guitar) and Mike Coxe (drummer).

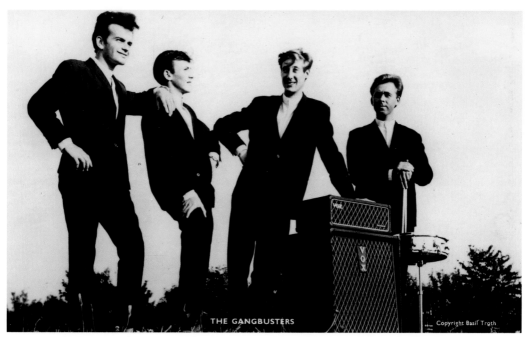

THE GANGBUSTERS Copyright Basil Troth

69

A Function in the Kine Croft, *c.* 1912

The Kine Croft was used for many things, including a cricket pitch and football pitch. Farmers were allowed to graze their cattle here and this continued into the 1950s. Today, Guy Fawkes Night bonfires are held here. Below, the BunkFest in 2012. The festival was started in 2002 as a summer folk music festival and over the last ten years has grown considerably, with dozens of Morris sides and folk singers performing over the two days.

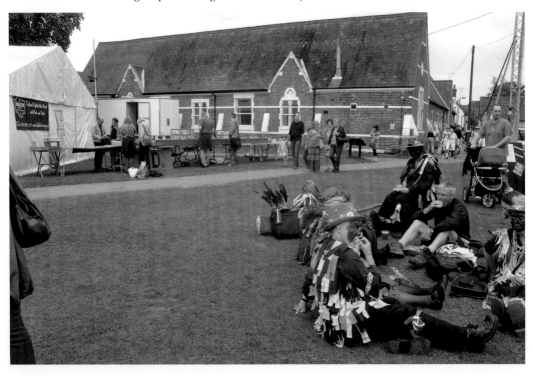

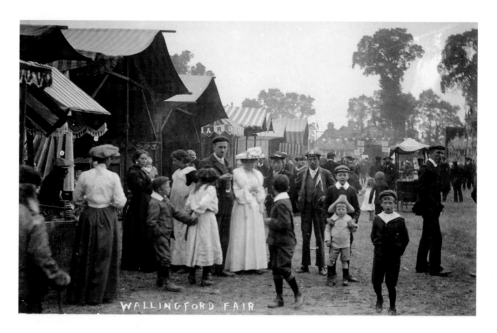

WALLINGFORD FAIR

Wallingford Michaelmas Fair, 1904

The fair was for farmers to hire their labour for the year ahead. Farm labourers would come not only from Wallingford but all the surrounding villages as well. Each man would wear in his lapel an indication of his trade and when hired he would put a piece of ribbon on his hat. The fair was originally held in the market place, but after the fair there was always a lot of horse dung to be removed. The fair still attracts large crowds. One thing that may have changed are the smells – from horses, oil lamps and the steam engines, to meats, sausages and fish being fried.

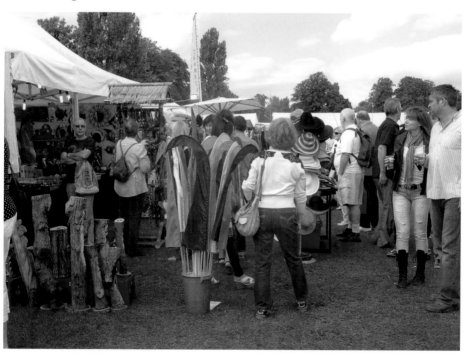

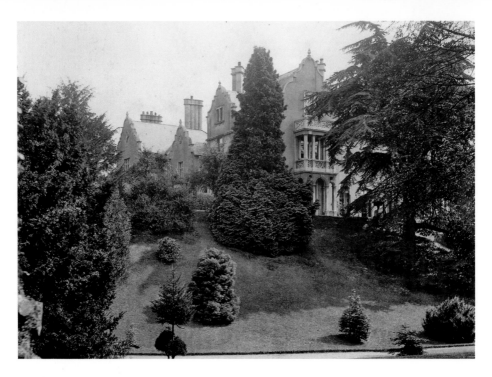

Castle House, *c.* 1900

The house was known sometimes as Castle Banks. It was the home of the Hedges family until it was demolished in 1972. John Kirby Hedges (his middle name was his mother's maiden name) was a solicitor, and he also wrote a two-volume book called *The History of Wallingford.* When he died in 1901, he was succeeded by Frances Hedges. Sir John Hedges (1917–83), his son, was the last Hedges to live at Castle House. The house was used a care home until it was demolished. After demolition, the intention was to build a retirement home for architects, but there were objections from the county council and the plan was dropped. The town now has a nice peaceful area to relax in and I'm sure John Kirby would approve.

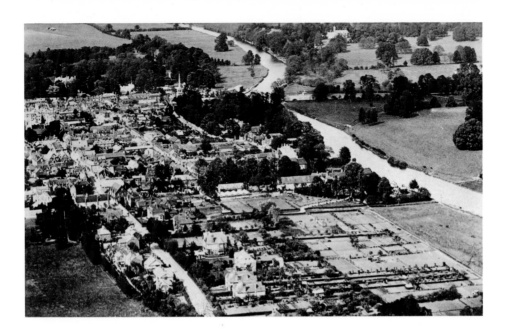

Wallingford, Looking North in 1920

Chalmore Gardens can be seen on the bottom right, with the gardens of St Lucian's just above them. Wallingford Bridge can be seen near the top and the toll-house is just visible. The house right at the top is Howbery Park. Below, Wallingford looking north-west in the 1990s. Watery Lane can be seen on the right. It is near the tree at the bottom of the photograph that a Halifax bomber piloted by Wilding and Andrews crashed in 1943, thus saving Wallingford from serious damage, although the author's bedroom ceiling did collapse onto him.

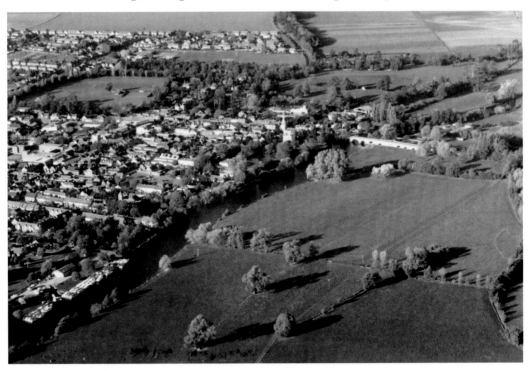

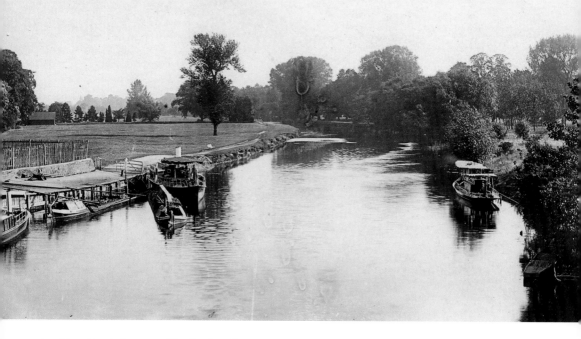

Looking North from Wallingford Bridge, *c.* **1906**

Canal Wharf is on the left. The owner was Thomas Bossom, a coal merchant. He had coal brought down from the midlands unloaded here from the barges, which were similar to the ones that can be seen moored on the quayside in the photograph. The building by the treeline is John Kirby Hedges' boathouse. Wharf House is on the left; it was here that Thomas Bossom lived from 1880 to 1920. Thomas Jones was the merchant before Bossom, and when Thomas died, George Frederick Phillips, a timber merchant, used the wharf from 1920 to 1938.

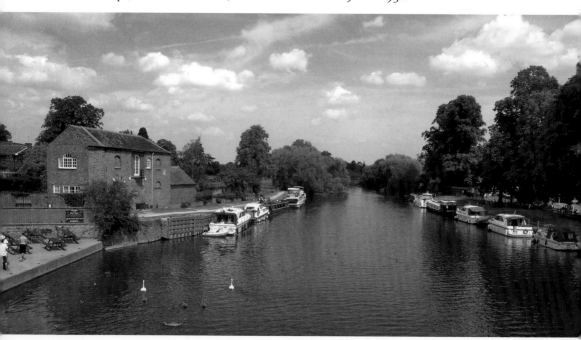

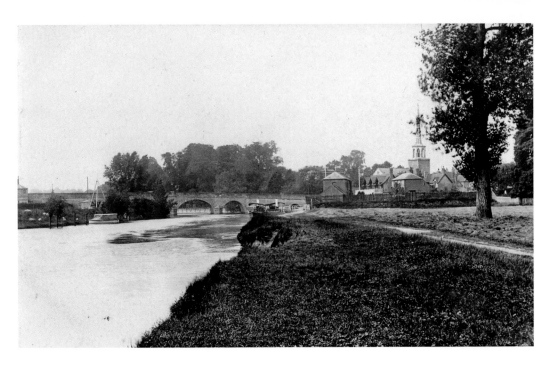

North Side of the Bridge, *c.* 1904

The name of this meadow on the right is Queen Arbour, sometimes known as Bossom's Meadow after Thomas Bossom, who lived at Wharf House. The toll-house can be seen on the left. The bank was kept clear of bushes because horses used the towpath to pull barges. Below, Queen's Arbour in 2012; note how close the towpath is to the river compared with the picture above. There are more trees and bushes in the picture, as there is no need to keep the path clear to allow horses to pass. This meadow is now part of Castle Meadows, which were purchased in 1999 by South Oxford County Council.

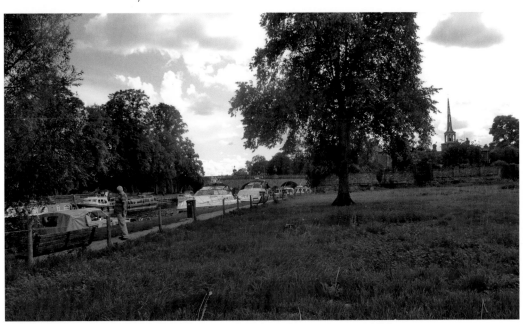

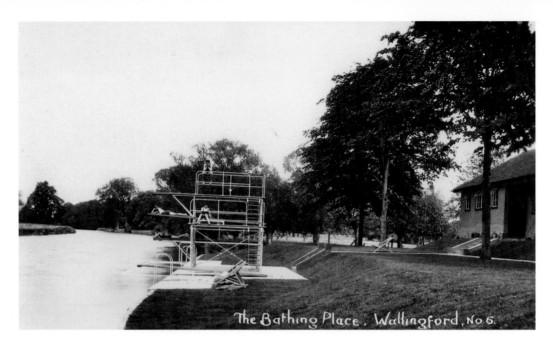

The Bathing Place, Wallingford, No 6.

The Diving Boards and Changing Rooms, *c.* 1936
The boards and building were opened on 22 May 1935 by the Mayoress, Mrs Lovelock, who stood in for her husband Harold when he was ill with a cold. Despite the cold weather large crowds attended the opening. In the distance can be seen a Second World War pillbox, one of three that that protected the river crossing between Howbery Park and the bridge. The area was improved in 2010 and moorings for river launches have been provided.

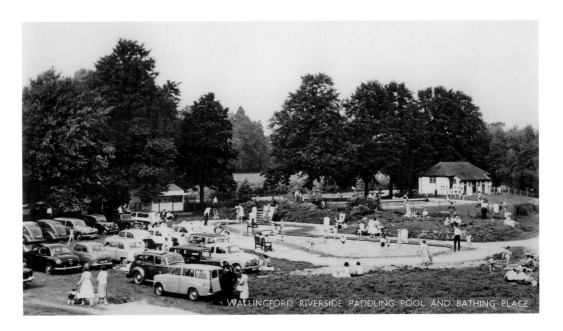

WALLINGFORD RIVERSIDE PADDLING POOL AND BATHING PLACE

Bathing Pool

The bathing pool was opened in 1952 by the then Mayor, Mrs Simmonds. The paddling pool was opened in 1955 as part of the 800th anniversary of Wallingford being a borough, and closed in 2011. The changing rooms, top right, were built in the 1936, and diving boards were erected on the river in front of the building. The paddling pool was converted into the Jubilee Splash Park for the Queen's Jubilee in 2012. A few years before the council had considered closing the paddling pool but after demonstrations outside the South Oxfordshire District Council offices they decided to keep the pool open.

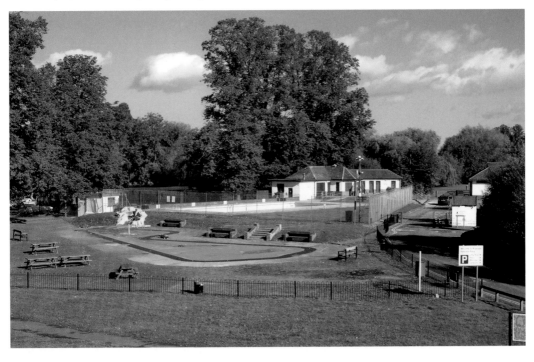

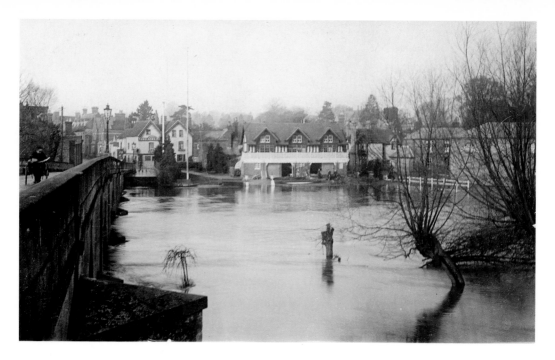

Thames in Flood

In 1904 the Thames flooded. There have been several higher floods than this, including in 1947, 1917, 1894 and 1809, when the water rose above the central arches causing that part of the bridge to collapse. Note that this was before the steps were built leading from the bridge to the bank. Below, the Thames in flood July 2007. In the last ten years there have been three other floods similar to this one.

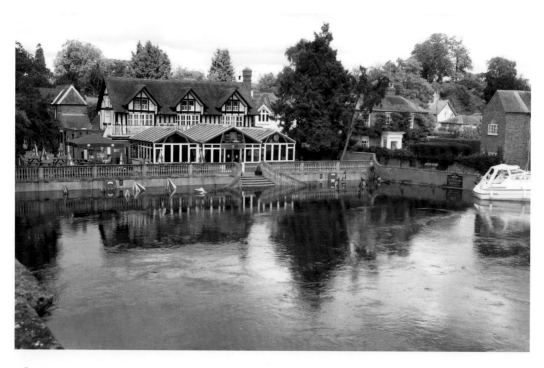

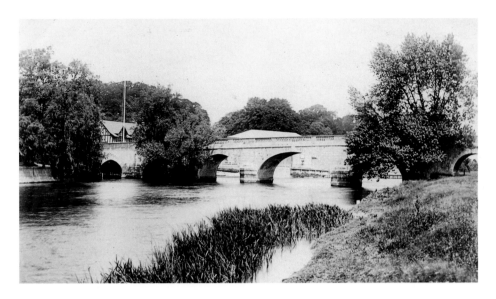

Wallingford Bridge, *c.* 1908

Large beds of reeds could be seen growing along the river edges but, with the increase of traffic travelling on the river and dredging, these reed beds were lost and erosion of the riverbank increased considerably, because the banks had lost their protection. Where the half-timbered building can be seen, between the trees on the left, was once the site of Wallingford gasworks. It was built in 1835, despite the protests of a group who called themselves the Anti-illuminators, who believed people would be poisoned by gas fumes from the street lighting. During 1874 part of the gasworks collapsed and the town was without gas for sometime; because of this the gasworks was moved to Station Road. Below, Wallingford Bridge in 2011. A youth organisation was running a canoe trip down the Thames for a week and stopped at Wallingford for a break. As can be seen in this picture, the banks have been badly eroded. Sitting on the bank on the right is Phil Leaver.

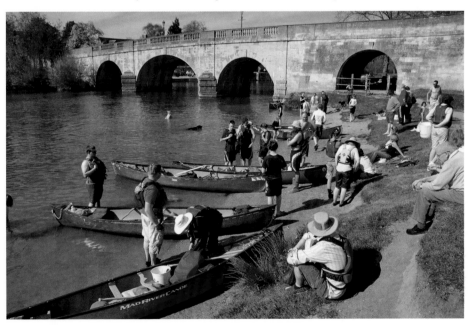

The Jack Ponds, by Henry Taunt, *c.* 1876

These ponds on the south side of the Wallingford Bridge were very deep and they were filled in around 1895. In 1892 there was concern that soil had been tipped into the ponds and killed all of the fish, which were mainly young pike, hence the name given to the ponds. In the same view today there is no sign of the ponds that used to be here, though at times streams will flow here, which probably fed the ponds. Bridge House can be seen in the distance, once the home of Colonel Charles Roberts, cousin of Lord Roberts VC of Kandahar. Charles moved to Wallingford in 1905 and became well known in the town. Always interested in the young, he helped form the first Scout troop in Wallingford. He died in 1926 and is buried in Crowmarsh churchyard.

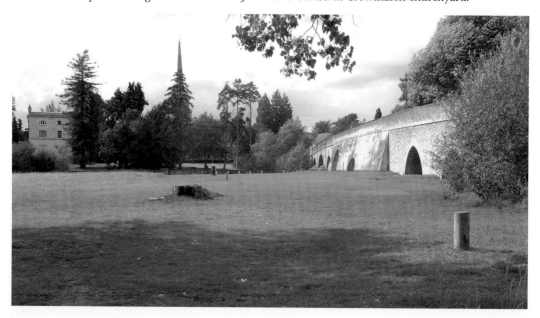

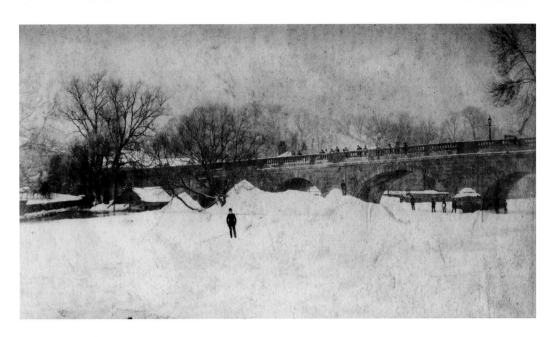

Frozen Thames

This photograph was taken in 1895 and shows the Thames frozen enough for a people to stand in the centre of the river, while the snow had drifted almost to the top of the arches. In December 1894 Britain was struck with the worst storm of the nineteenth century followed by twelve weeks of frost. By February 1895 the Thames froze and in London the ice was some 6 feet thick; 33 degrees of frost was recorded in Wallingford. The snowfall of January 2013 was quite heavy, although there have been many winters that have been worse. The winters of 2009/10 and 1963 were far worse, but the snowiest winter on record was 1947, when the snow thawed in late March. It went on to cause some of the worst flooding of the Thames at Wallingford since 1894.

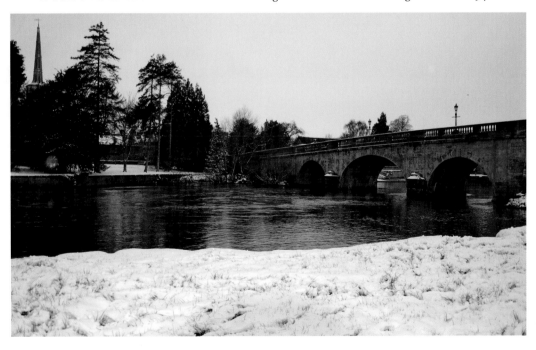

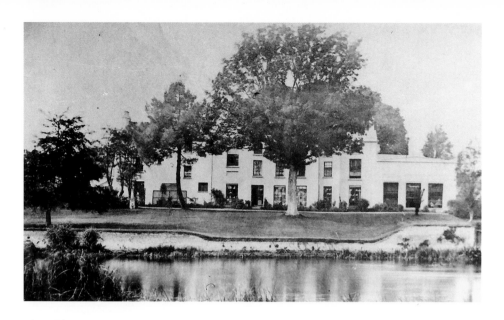

Riverside House, *c.* 1870

The artist George Dunlop Leslie lived here from 1894 to 1907. Percy de Mouchet Cavell then lived here in 1911, followed by George Potts in 1915 to 1935. By 1939, Richard Wilder had bought the house. Below, rowers passing Riverside in 2010. The house at one time was the home of Tim Wilder, and when he died in the house was converted into flats, one of which was bought by an American who bought all the other flats, one by one, and converted Riverside back into a house again.

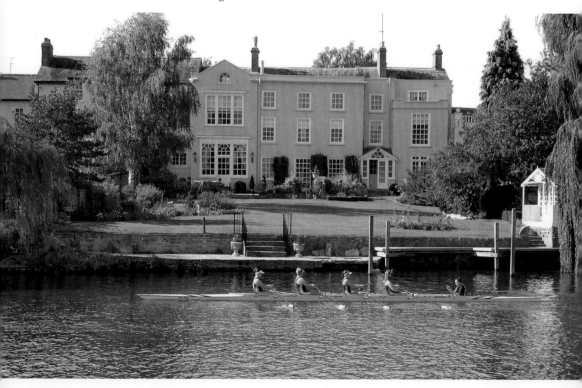

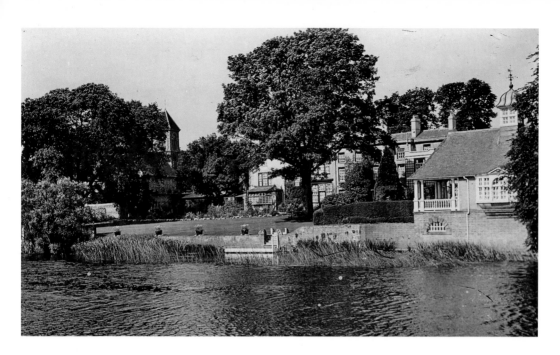

Riverside

George Dunlop Leslie was a member of the Royal Academy. He moved to Wallingford in 1883, living here until 1907. The boathouse on the right was built in 1892. George Dunlop and George Hayllar painted the picture of Queen Victoria, which now hangs in Wallingford town hall, to commemorate her Golden Jubilee. Below, the boathouse today. At one time the river was heavily silted up but has recently been cleared out.

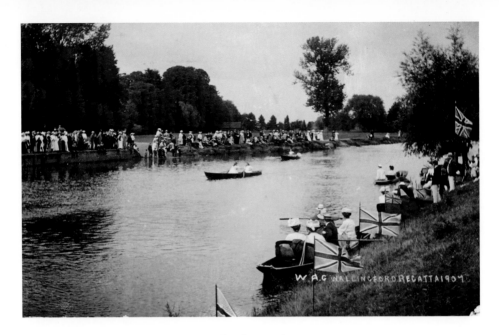

Wallingford Skiff Regatta at Lower Wharf, *c.* 1906

The land the spectators are standing on was owned by Percy Turner, and was where he built and hired boats. He also gave swimming lessons by holding students from a fishing-rod-like contraption supporting them around the waist and suspending them over the water. Percy Turner was well known for singing comic songs, and often after the regattas he and Dr Walter would entertain the crowd. Oxford University Boathouse (the original boathouse on the Isis at Oxford) was burnt down in 1999 and most of their archive material was lost. After five years of fundraising, a new boathouse was built at Wallingford at the cost of £2.5 million. It was designed by Tuke Munton and was opened in 2006. The building was built on an area used during the Second World War to test Bailey bridges and was known locally as 'The Concert'.

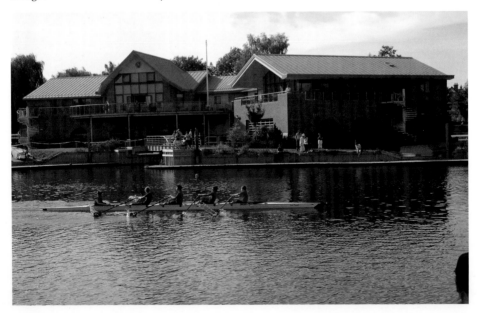

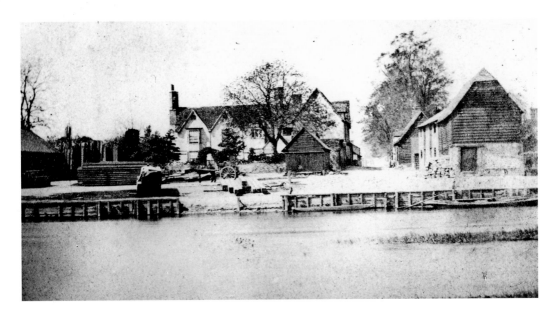

Lower Wharf, *c.* 1876

At the time this photograph was taken the wharf was owned by William and John Hilliard. They were timber, coal, salt and slate merchants, as well as being auctioneers. Wharf House, in the centre of the photograph, was renamed St Lucian's in 1888, when it was purchased by Richard Wilder. Below, Lower Wharf in 2012. The building on the right was used as a rifle range until a new was one built in St John's Road in 1910. The building is now a private house. The flood of 2003 flooded the living room here.

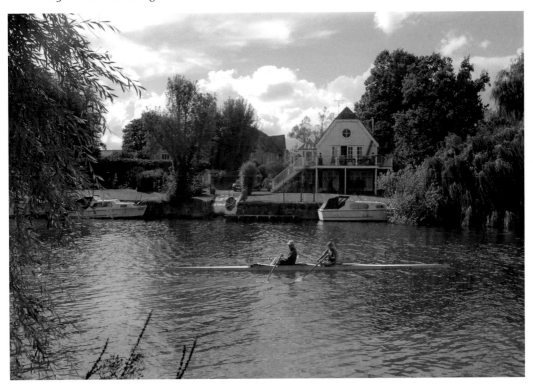

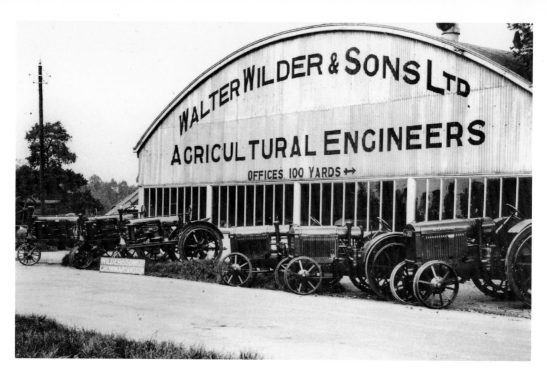

Walter Wilder's Agricultural Works in Crowmarsh, *c.* 1920

The International tractors seen here were sent over from America and assembled at Wilder's. The dome-roofed building is believed to be a First World War hangar, brought to Crowmarsh in bits and assembled by two men and a boy. Below, the demolition of the workshops. They had been used by Crowmarsh tyres for a number of years until 2011, when the development of the site began. The site now has over forty houses and flats built on it, and is known as King Stephen Place and Bellamy Way, named after a prominent local councillor.

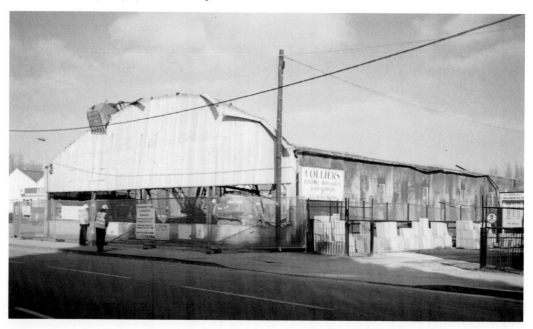

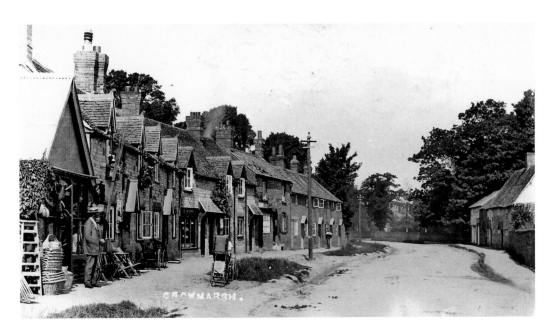

The Street, Crowmarsh, *c.* 1905

Joseph Philips is standing outside his shop on the left. He was a carpenter and undertaker. After his house was E. Norris cobbler's, and two houses along is the Game Cock Inn. Because of the licensing laws, which made pubs in Berkshire close at 10.30 p.m. and in Oxfordshire at 11 p.m., Wallingford men would run over the bridge from Berkshire to Crowmarsh, Oxfordshire, for the last half-hour of drinking. The Game Cock Inn was closed in the around 1960 and it was demolished in around 1967 when the Newnham Estate was started. The old cottages beyond the pub were demolished in the 1970s.

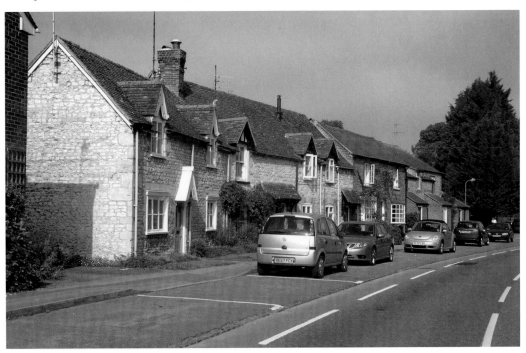

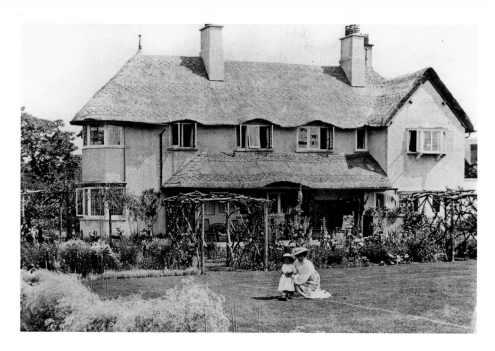

Crowmarsh Houses

The plot of land for this house was purchased in May 1902 for £300 by a Mr Ellis, a former Mayor of London. A relative of his, a Mr Corbold-Ellis, a London solicitor, had the house built in 1903 and moved in the following year. Mrs Corbold-Ellis was an excellent cameo portrait painter; in fact her grandfather taught Queen Victoria to paint. In June 1904 she gave an exhibition of fifty of her miniatures to invited guests. In 1909 they moved back to London and rented the house out. In 1909, the roof was badly damaged in a fire. The thatch was replaced with tiles. The house was pulled down in 1967 to make way for the entrance to Thames Mead housing estate. Crowmarsh had once again lost an interesting historical house to the developer.

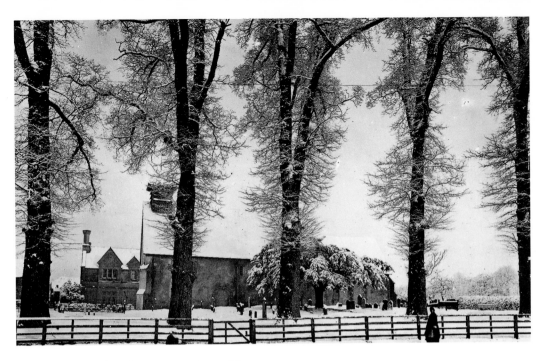

St Mary's Church, Crowmarsh, *c.* 1880

The elms were felled in February 1882 and the brick wall, paid for by public donations, was built in place of the fifteen-year-old wooden fence; a gate in the wall and a gravel path was built for access to the rectory on the right at a cost of £60. The lychgate and memorial to the men from Crowmarsh killed in the First World War was dedicated on 31 December 1919 before a very large crowd, despite the wet and windy weather. The Revd Dams, a former vicar of Crowmarsh, was invited to say a short prayer; the dedication was performed by the Revd Fulford, vicar of Crowmarsh.

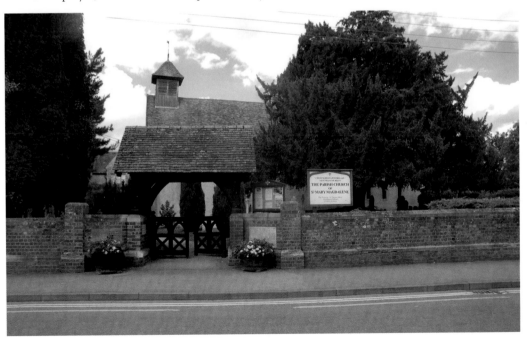

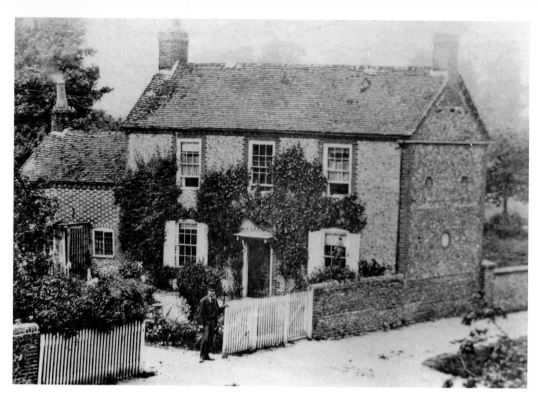

George Philips House in the Street, Crowmarsh, *c*. 1880
The house was built around 1775 on to the wall each side of the gates, the wall being much older. Originally it had a staircase that was a fine example of Georgian carpentry. Now a builder's yard, the garden has been concreted over and its former glories are lost forever.

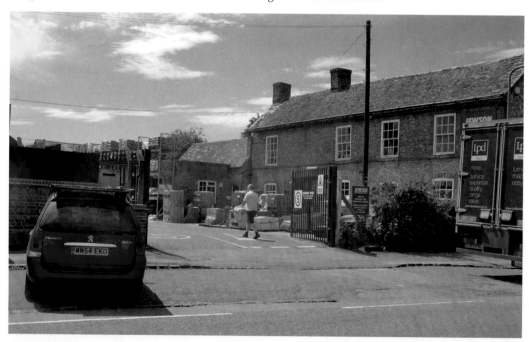

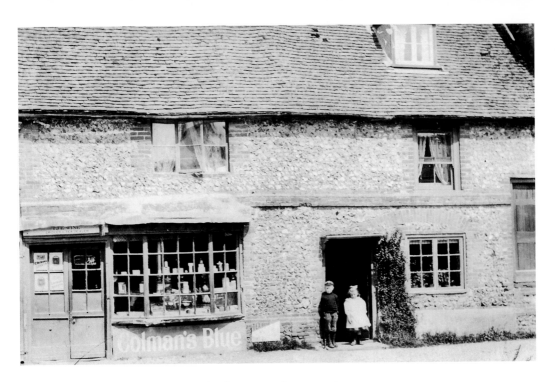

Mr Isaac, Wise General Store in the Street, Crowmarsh

Mr Wise was also an undertaker; he kept the horse that pulled the hearse in his garden. The only way to the garden was through his house, so he had to take the horse through the house and out through the kitchen. The building is now a private house, though bay windows can still be seen. In fact, there has been little change to this building in 150 years.

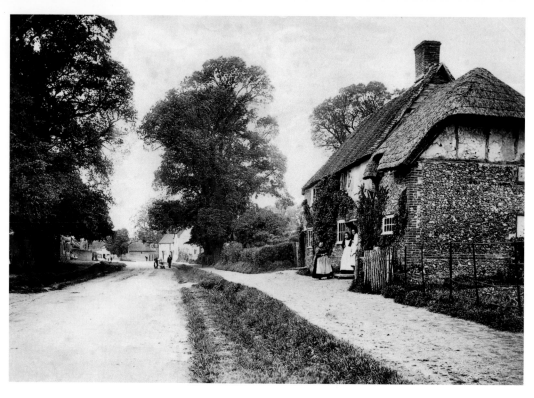

Cottages, Crowmarsh

A picture taken by Henry Taunt in 1890s. The Bell public house can be seen in the distance on the right. The cottages were demolished around 1933 and when the present house was built the grass verges were considerably widened.

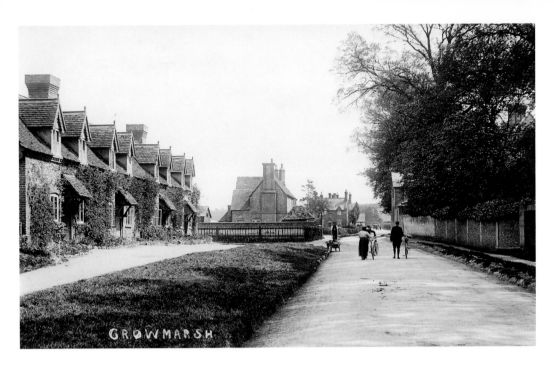

The Dormer Cottages, Crowmarsh, *c.* 1908

These cottages were scheduled for demolition in 1942, but it was not until the early 1970s that they were finally demolished. The cottages were just two-up, two-down. Mr William Wigley, who lived in one of the cottages, had five children – two boys and three girls – making the sleeping arrangements quite interesting.

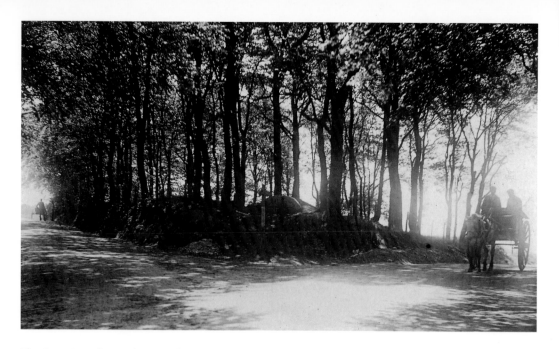

The Junction of Woodcote and Goring Roads, 1906

The hump in the centre is the top of the Mongewell Park icehouse. The icehouse was about 2 metres deep and was brick lined. When in use it would also be lined with straw, and ice could be stored there all summer. It was considered to be one of the finest icehouses in Oxfordshire and was demolished in 1974 to make way for road improvements. Below, looking north towards Mongewell roundabout. The roundabout was part of the Wallingford bypass. When the bypass was opened in July 1993, all the beech trees that lined the road on each side were removed and so an area of beauty was lost and replaced with this modern development.

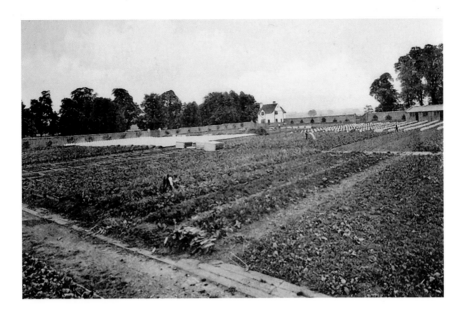

The French Gardens, Howbery Park, 1913

French gardening is a form of intensive gardening developed in France in the 1900s. Fruit and salad are forced out of season, using bell-shaped cloches and glass frames. Harvey du Cros opened his garden in 1909. The plants had to be watered each day, which made it very labour intensive. Mr du Cros employed a number of Frenchmen and local boys during their school holidays. In the picture you can see the strawberry beds. The photograph below looks in the reverse direction to the picture above. When the South Oxfordshire District Council offices were opened in 1982, there was local protest and pickets outside the entrance to the site.

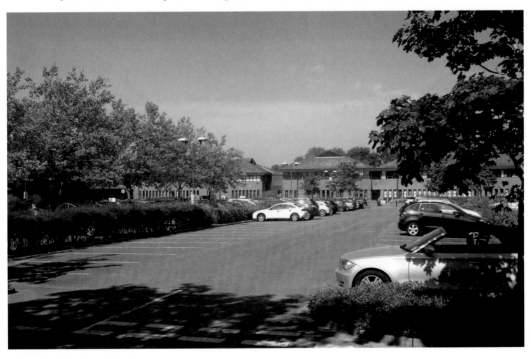

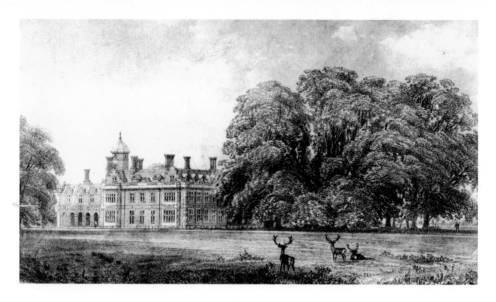

Howbery Manor House, 1854

The have been several manor houses on this site. One burnt down in 1757, and a new house was built in 1760. When the owner Lord Kilmorny went to Ireland, the house was allowed to become a ruin. In 1833, William Blackstone MP purchased the park. He employed Mr Hakewill to build a new house, but became bankrupt and the house was left unfinished until 1858, when Count de Mornay purchased it. He finished it in 1860. In 1868 he sold it to Williams-Wynn; the above picture is taken from a sale catalogue of that date. Williams-Wynn lived here until his death in 1895. In 1902 Harvey du Cros purchased the house and grounds. He died in 1918, and in 1920 George Faber (Lord Wittenham) became the owner, until he died in 1933. The house was requisitioned during the Second World War. Below, Howbery Park Manor House in 1960. In 1949 the government purchased the house and grounds and the Hydraulics' Research Station was set up. Its remit was to research coastal erosion, flood protection and the silting and scouring of rivers, estuaries and harbours worldwide. The company was privatised in 1982 and is still running today as HR Wallingford.

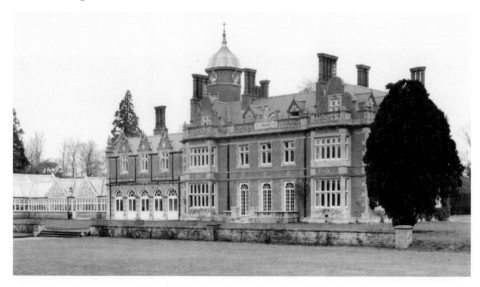